W9-AQA-531

the SHABBY CHIC *home*

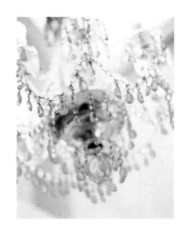

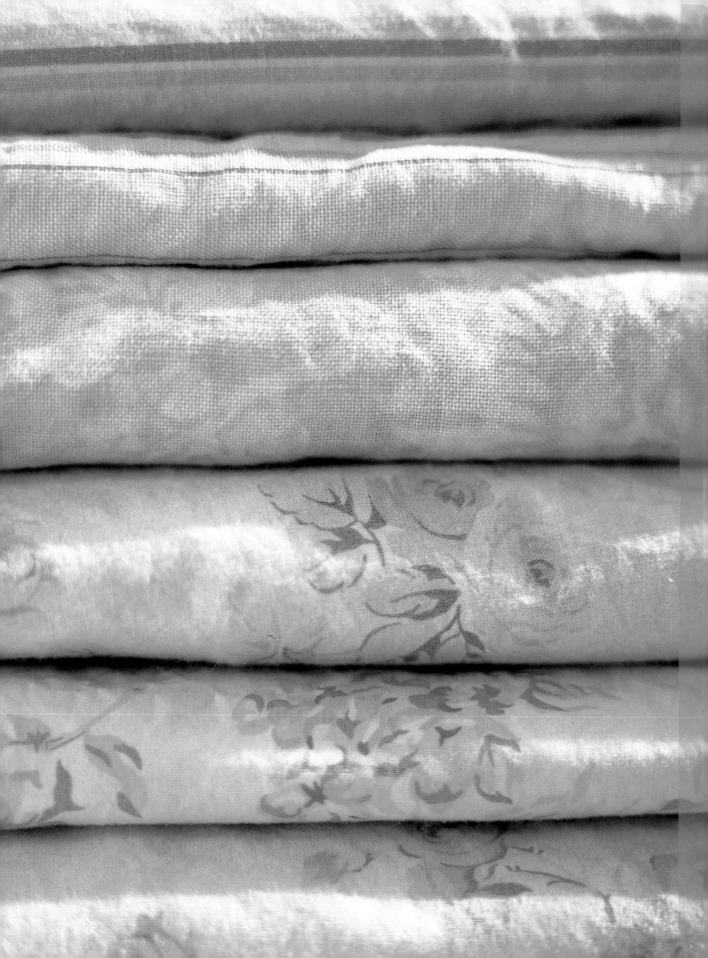

the

SHABBY
CHIC

home

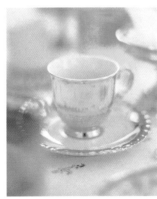
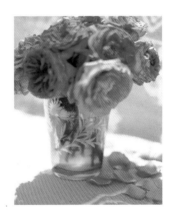

Rachel Ashwell

photography by AMY NEUNSINGER
sketches and illustrations by DEBORAH GREENFIELD

HARPER
DESIGN

An Imprint of HarperCollinsPublishers

HarperCollins books may be purchased for educational, business, or sales promotional use.
For information please write: Special Markets Department,
HarperCollins*Publishers*, 10 East 53rd Street, New York, NY 10022.

Published in paperback in 2012 by:
Harper Design
An Imprint of HarperCollins*Publishers*
10 East 53rd Street
New York, NY 10022
Tel (212) 207-7000
harperdesign@harpercollins.com
www.harpercollins.com

Distributed throughout the world by:
HarperCollins*Publishers*
10 East 53rd Street
New York, NY 10022

Library of Congress Control Number: 2011945588

ISBN: 978-0-06098768-8

Printed in China, 2012

Designed by Gabrielle Raumberger Design, Santa Monica, California:
Gabrielle Raumberger, Clifford Singontiko, and Charles Rue Woods
Sketches and illustrations by Deborah Greenfield
Text by Annabel Davis-Goff

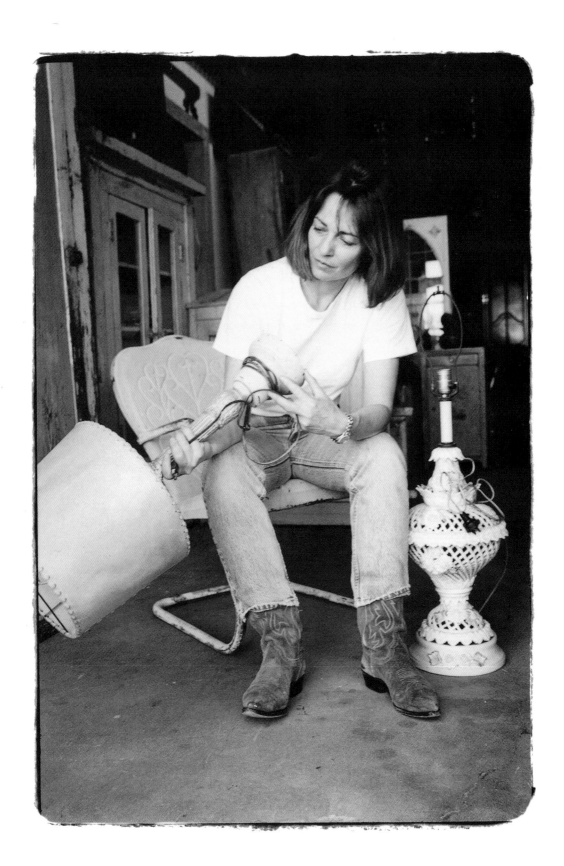

Contents

Acknowledgments

Amy and Tom, you really made this project fun and so very beautiful. It's as if we lived together for a short while, and at the end of the project you knew all there was to know of my home and life.

Annabel, thank you once again for your words and humor.

Deborah, my sister, your lovely drawings add that third dimension. Thank you.

Gabrielle and Cliff, your patience and input are always so comforting.

And Lupe, thank you for taking care of this house as though it were your own. You enable me to do projects like this.

Thank you to my publisher, Judith Regan, who is now also a good friend.

Last, thank you to my friends who visit my home, without whom there would be little point in having a house.

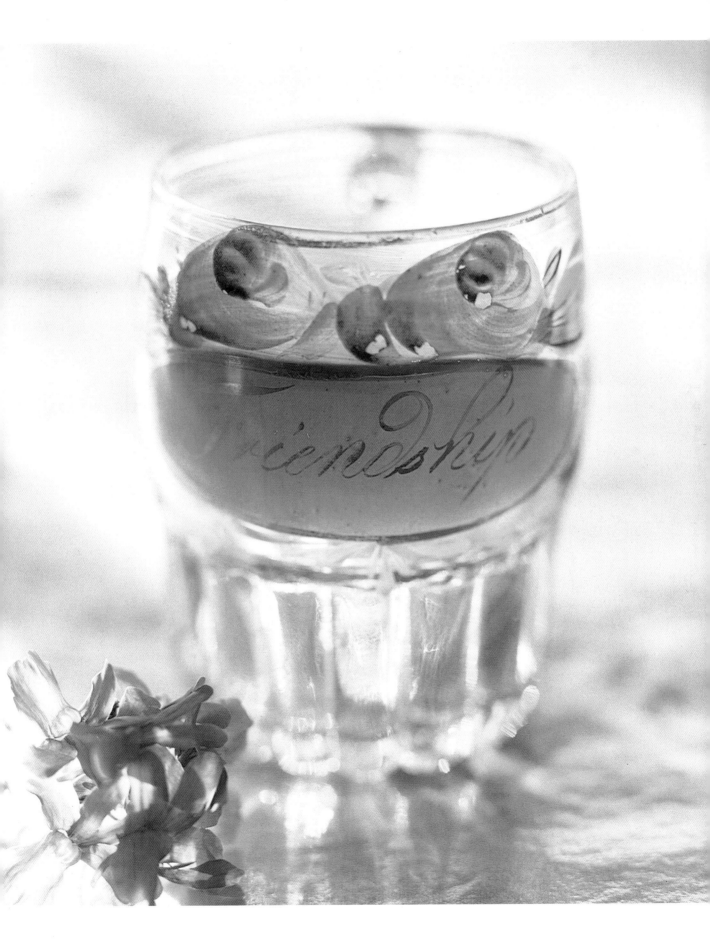

the
SHABBY
CHIC
home

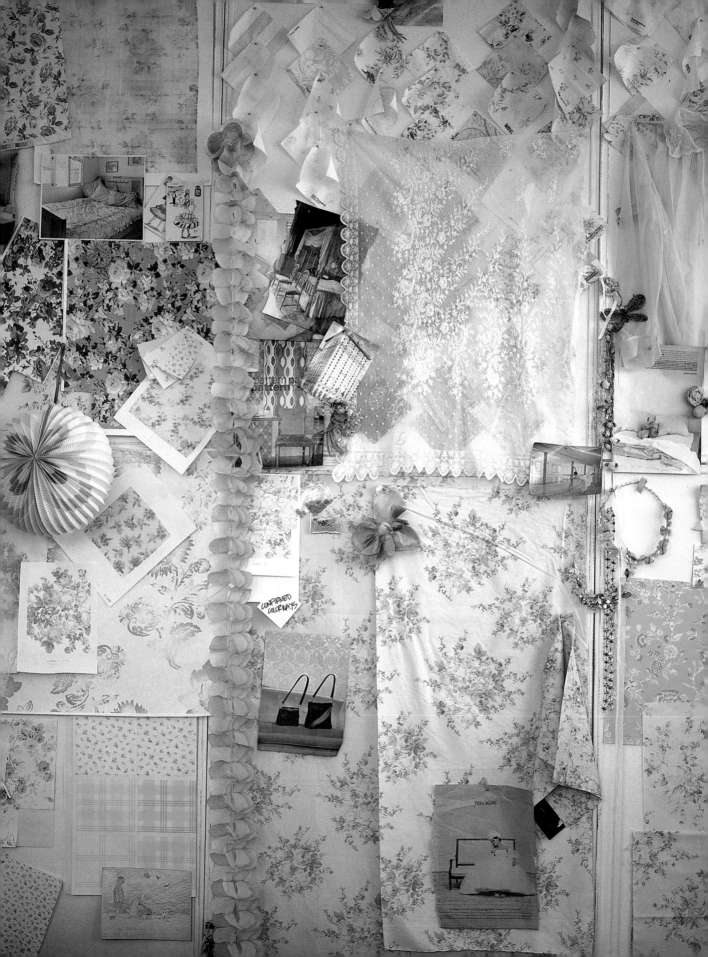

Introduction

Before I bought my house—my *home*—my children and I lived in a rented house. I was waiting to make the commitment. I had been waiting nearly nine years, since my divorce, believing it would be a commitment to make with another person. Similar to another romantic, special thing I was saving: a visit to Italy. In 1998 I did both, with my children, Lily and Jake.

Making the commitment was the beginning of a long process, which might have been longer had I not clearly known my criteria. I wanted an old house, and I wanted to live close to the beach. I was working within a budget and knew that these requirements would not make the search easy. I wanted an old house because I need certain qualities that go with an old house: thick walls, thick doors, stone work, old fireplaces, and a general level of workmanship you don't find in new houses. And I didn't want to move from Malibu or from the beach; the location was important not only because of my children, but because I wanted the immediate surroundings of my new home to reflect the tranquil atmosphere I planned to create within it.

Fortunately, my third requirement was that it should not be too large, which helped balance the budget. I wanted a house that was big enough for all three of us to have a measure of privacy, but I did not want it to be so large that we would lose the sense of intimacy we'd had in our previous home. I didn't want us to live somewhere that we would expand into, to find ourselves filling closets with clutter and unnecessary acquisitions, to grow into our space by giving up simplicity. I wanted my home to fit my life, and I did not want to become a caretaker to a large house.

I had one other requirement: a garden. A pool would be a bonus, but a garden, even a small one, was a must.

Opposite: I see my inspiration boards every single day: filled with colors and shapes I want to remember, and with things that are simply pretty. If a fabric for a new project is missing a color, or its texture eludes me, I turn to these richly layered boards to release my creative juices.

The most beautiful things in the world cannot be seen or even touched—they must by felt with the heart.

—HELEN KELLER

DUVET
W/ZIPPER

RUFFLED
DUVET

RUFFLED
BEDSKIRT

STANDARD
W/ZIPPER

STANDARD
W/RUFFLE

KING
W/ZIPPER

KING
W/RUFFLE

30" EURO
W/ZIPPER

30" EURO
W/RUFFLE

BOUDOIR
W/ZIPPER

BOUDOIR
W/RUFFLE

COMFORTER

BEDCOVER

COVERLET

color

I had some other thoughts and wishes, not quite tangible enough to list for a broker. I felt the need for more color in my life, and I wanted to have some control over what was outside my house. For some time I had found the ocean view at my previous house a little melancholic in conjunction with the pale colors and tattered elegance of Shabby Chic. And although I remain as loyal to my palette (pale pink, pale green, cream, and white) as I do to my three decorating and furnishing maxims (beauty, function, and comfort), I wanted to add colors that leaned toward fun, youthful exuberance, a Caribbean atmosphere. And I wanted to look at views that gave me back some color, through windows that did not need curtains; views that allowed for a way of living in which the indoors became outdoors without the feeling of having crossed a boundary.

Although all these criteria were met in my new house, at first sight I did not realize it. My initial reaction was that the house was dark, spooky, witchy. The house itself was dark brown, inside and out; the neglected pool was swampy with black walls; the garden, gloomy and overgrown. The house was reached through a dark tunnel of brown walls that opened out to foliage and trees so thick that they did not let in light. My daughter was frightened by it. It was so diametrically opposed to everything I stood for that I was surprised my broker should have thought it worth showing me. And yet days and even weeks later, the house kept coming back into my thoughts, and I would hear it talked about. I heard that it still hadn't been sold.

Opposite: Work in progress.

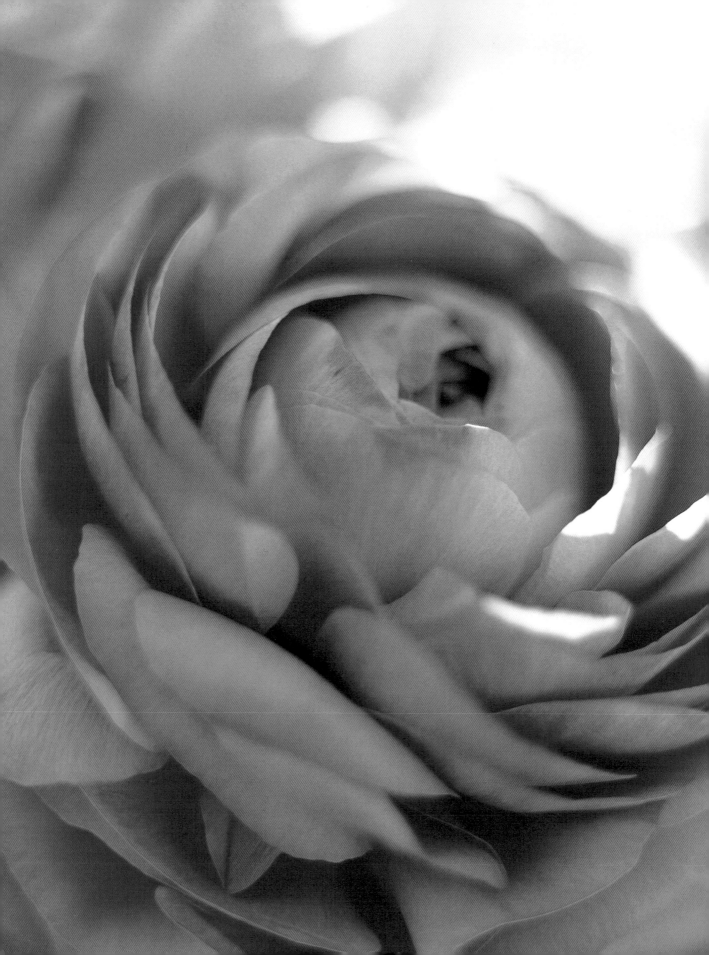

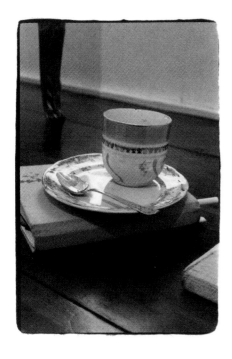

I asked my broker to arrange another visit. This time I walked in and instantly saw what had to be done. I could see the house's bones—its wonderful wide-plank floors, its old paned sash windows (a rarity in Southern California)—and I fell in love with them, and with the house.

Buying the house was a protracted transaction—no one's fault—and it took nearly a year before I owned it. It was as though I were being tested over and over again as to whether I really did want the house. At times this caused me to think hard, but never to worry.

In renovating the house, budget was again a consideration, so I walked through my new house with my contractor and made two lists: the first, which would account for three quarters of my budget, included the essentials; the second, a wish list of alterations and changes to be done as I could afford them.

It was just a question of getting the house back to its bones. It had been built by a Swedish boatbuilder at the end of the 1920s. His maritime background can be seen in the magnificent floors—very wide and irregular planks—and the basic but securely latched storage areas. A *Hansel and Gretel* theme had been added by a subsequent owner, presumably in the 1940s, and some slicked-up kitchen and bathroom details reflected the taste of later owners. I wanted to take the house back to its origins and then add my own decor.

The essentials all worked toward the same idea: to give the house and grounds light and life. The greater part of the house and guest house were to be painted white, the trees were to be thinned to let in the sun and the sky, the dark pool was to become a turquoise one, and everything that was sad, depressing, gloomy, or downright squalid was to be removed.

Opposite: The heart of a ranunculus.

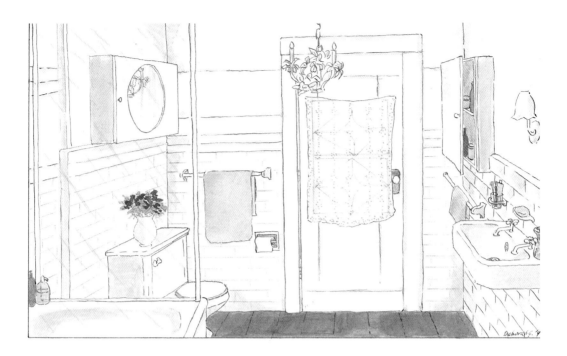

My contractor was surprised that I didn't want to take the opportunity to make larger bathrooms by ripping down walls. But I don't believe in the casual gutting of a newly acquired house. At times my decisions were budget-driven, but even if I could have afforded it I wouldn't have indulged in change merely for change's sake. Rather than gutting a house, I think it makes more sense to keep looking until you find a house whose bones you love and respect, then remove what doesn't work and build on the bones. I leave myself open to the influence of the house itself, rather than imposing my own preexisting ideas on it.

This book is an account of acquiring a house, decorating it, making it a home, and living in it. It describes how I find fixtures and furniture, and look for treasure; how I allow the house itself to give me ideas, to feed my inspiration; how a garden expands my range of color and shape; how I entertain my friends; and how my children and I live in it. This book is an exploration of the expansion of my taste, the progression of my aesthetic ideal and ideas. It explains how I decide what to leave alone, and how I live with small imperfections, and even, sometimes, make a virtue of them.

The ache for home lives in all of us, the safe place where we can go as we are and not be questioned.

—MAYA ANGELOU

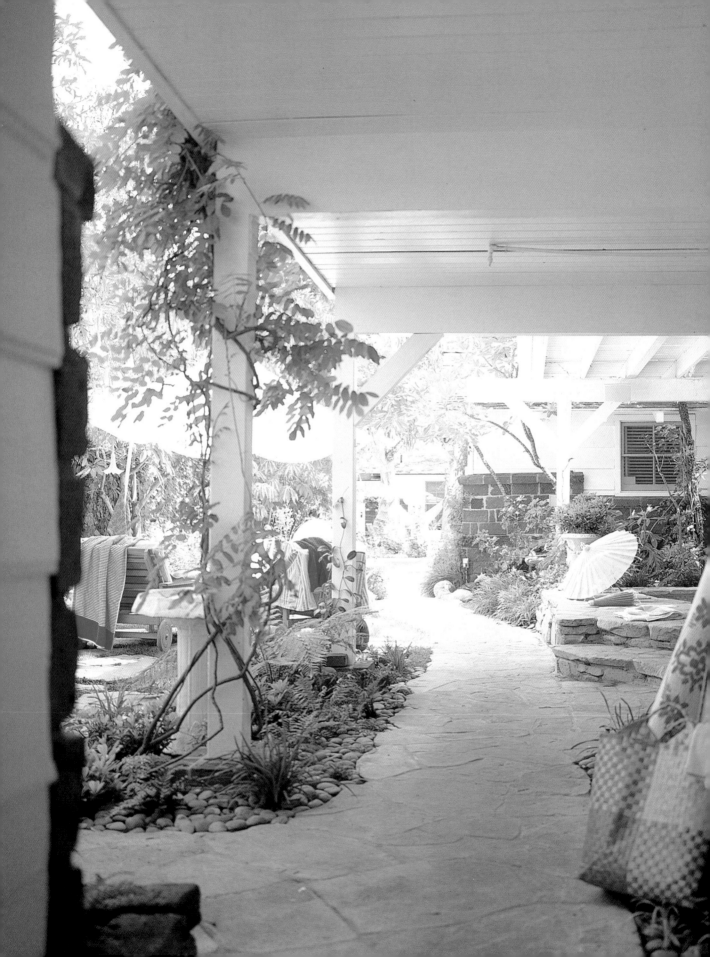

1

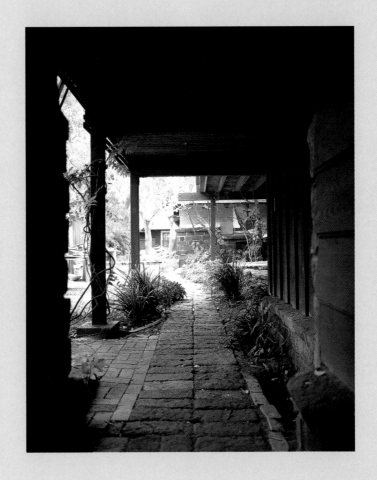

BEFORE
& AFTER

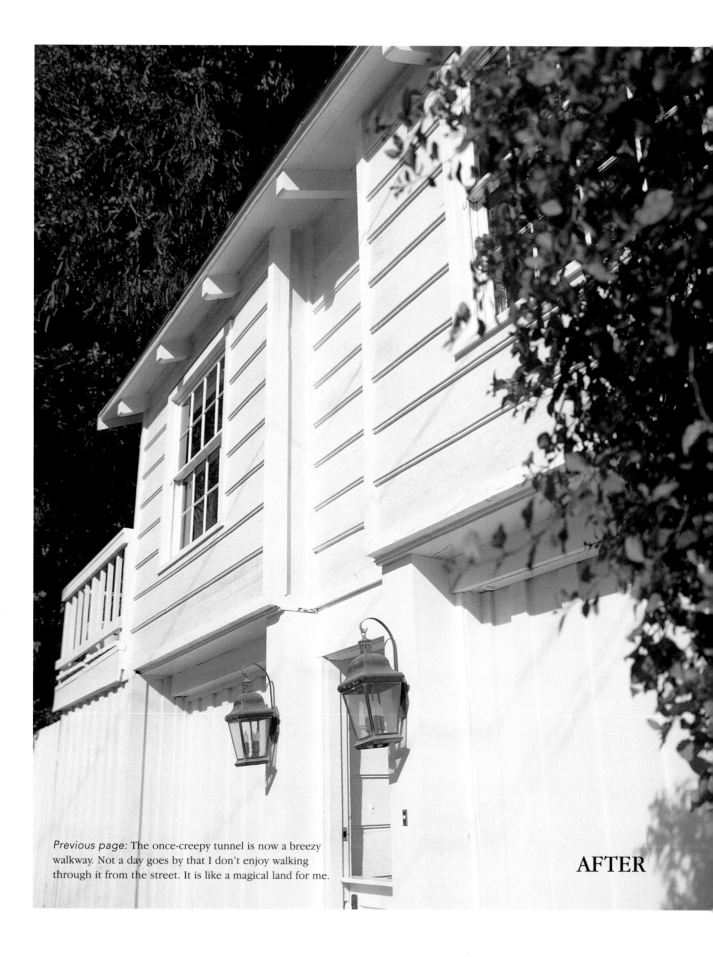

Previous page: The once-creepy tunnel is now a breezy walkway. Not a day goes by that I don't enjoy walking through it from the street. It is like a magical land for me.

AFTER

The Garden & Outdoors

When I bought my house it was a landmark in the neighborhood: the dark wood and huge craggly shutters, painted turquoise, suggested the witch's house in *Hansel and Gretel*. To add to its sinister, mysterious quality, what appeared from the street to be the front door really led into a long, dark passage under the guest house that ended in a dim and overgrown garden. The garden and the out-of-control creeping ivy were home to a large and healthy population of rodents.

Even so, I had bought the house with plans to renovate, not to remodel entirely. I had chosen a house with an infrastructure that did not require rebuilding: It had a sound roof, and the plumbing and electrical wiring were in good condition. With children to raise, a business to run, and a life to lead, I simply don't have the time and money to do work that's not completely necessary. And, anyway, it is more in my nature to ask "Can we keep it?" than to say "Let's tear it out." What I got rid of had to go; I dispose of nothing lightly.

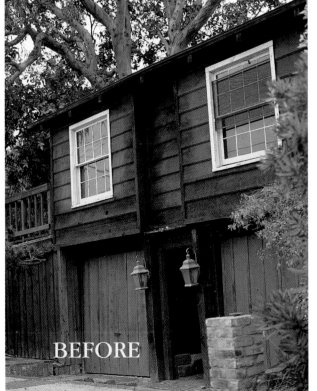

BEFORE

Left: The exterior of the house. Before, it was dark and a little spooky. The turquoise trim didn't help, but coats and coats of white paint did. Indoors, I don't like two tones of color, but on the exterior of my house I like this semi-gloss on the façade and the detail of gloss on the trim.

17

Painting, renovating the pool, thinning the eucalyptus trees, and clearing the jungle aspect of the garden were all part of my list of essentials. All three—representing three quarters of my renovation budget—were aimed at making the house and the garden lighter.

My budget allowed me to spend between 10 and 15 percent of the house's purchase price on renovation. This comparatively modest percentage was adequate, in part because I did not have to tear up anything to rewire or to replace pipes. I could avoid structural alterations, and hence dealing with too much of the unknown, which is where costs tend to get out of hand.

Right: The outside hallway and backyard before renovation—dark and witchy.

Opposite: The witch's haven has been replaced with a heavenly view. I shake out my sheets and look at the lovely setting below—a sun umbrella and teak chaises on the grass and stone. I tried to put down a lawn, but it was impossible because of the shade of the eucalyptus and the chlorine splashed by the children getting in and out of the pool. So a compromise of flagstone and grass was arrived at.

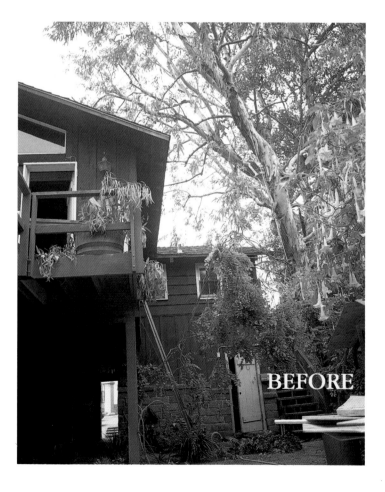

BEFORE

AFTER

inspiration

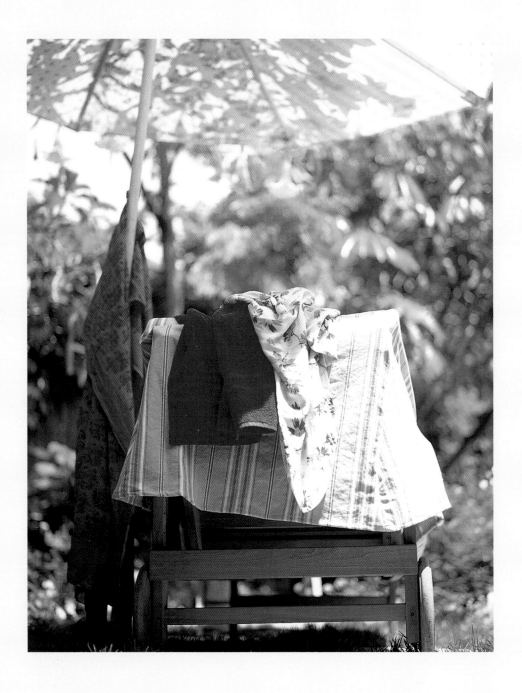

Above: I had slipcovers made to cover the teak chaise. The bright striped pink fabric is further evidence of my inspiration from the colors of the garden.

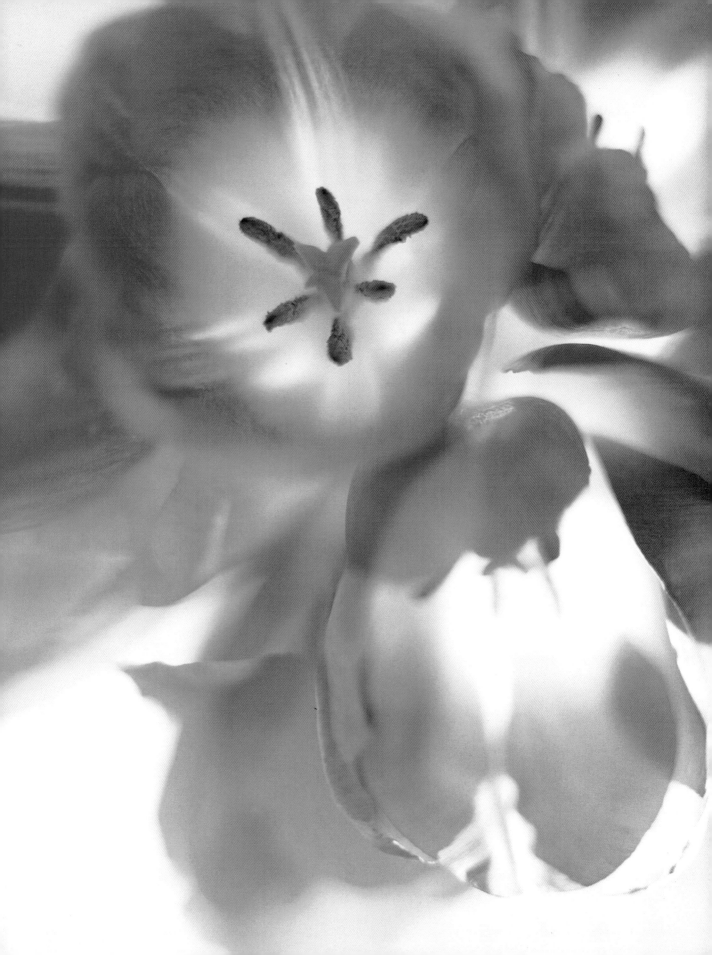

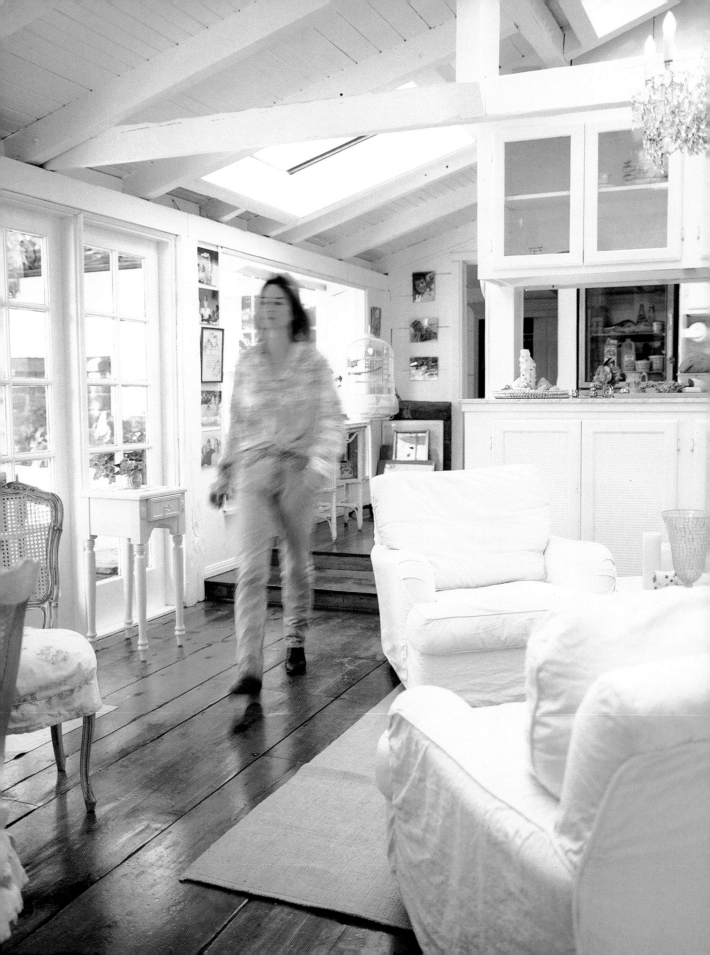

P A I N T

Broadly speaking, there are three kinds of paint:

- Matte: the flat paint used to paint interior walls.

- Semi-gloss: for baseboards and trim, and for kitchens and bathrooms, where the paint is exposed to steam and moisture.

- Gloss: too shiny for indoor use, but good for front doors and some exterior trim.

All paint should be applied to a clean, primed surface.
The choices of colors are immense:

- Paint colors look different on walls from how they seem on charts, so paint a sample strip before buying enough paint for the job.

- White has as many variations as other colors. When you are planning to paint a room white, you probably don't want a pure white, unless you like a hospital effect.

- Linen white gives you a white that is not too cold.

- Paint shops will mix colors to your specifications and their computer-assisted processes give an almost infinite range. Remember that custom-mixed colors cannot be returned or exchanged.

My largest investment was in painters and white paint. Although painting the interior and exterior wood took away from the original nature of the house, it was totally necessary to cover it with coats and coats of white paint. On the first day of renovation, the painters arrived: Sergio and his loyal—and appropriately white-uniformed—crew were to be there for many weeks. Before they started to paint they carefully peeled back the wisteria and jasmine so that the plants wouldn't be damaged. Then they prepared and primed the wood. Then they painted. The wood was porous and drank in coat after coat after coat of white paint. Other workmen came and went, but Sergio was there until the very end, even a little after.

Opposite: After gallons of white paint, even on the wicker-front cabinets, light was born. I chose not to have curtains in this room; privacy is not an issue since the house is enclosed by trees. I love the inside-out feeling—except when a raccoon is peering in at me.

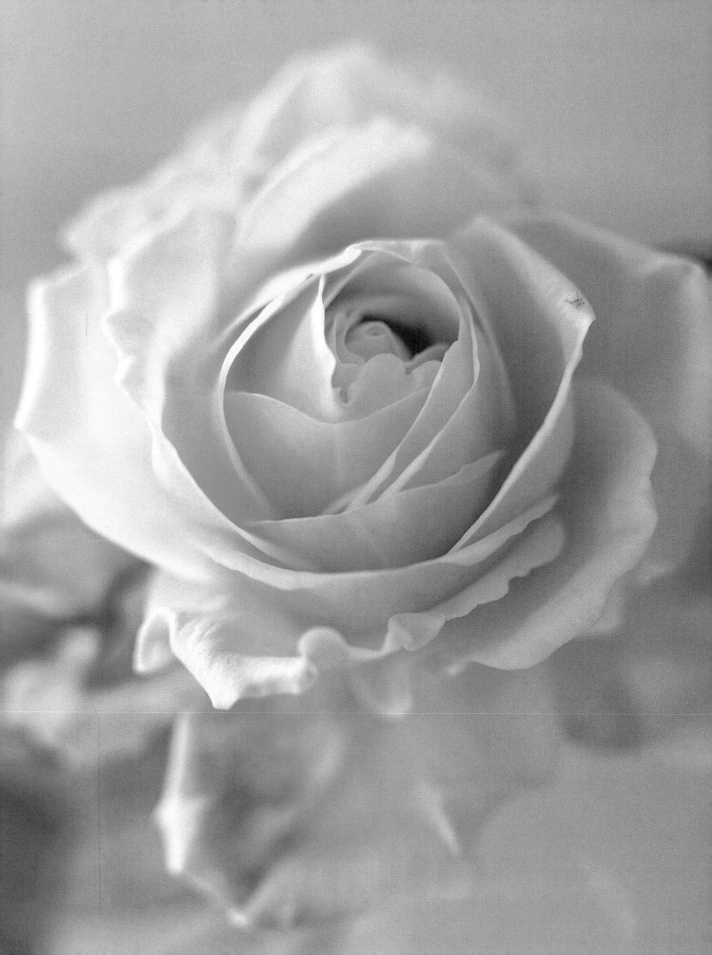

The garden was home to many lovely plants, bushes, and trees—as well as to the "blackout" eucalyptus, whose leaves killed the grass and clogged the pool drains, and the "rats' ladder" ivy that covered and strangled house and garden alike. Tree ferns, catalpa, old-fashioned roses, morning glories, honeysuckle, wisteria, heavy, sweet-scented jasmine, and angel's trumpets were revealed in the clearing process. They were lovingly pruned and cared for by Laura, my landscape gardener, who had worked with previous owners and had known the property for more than fifteen years.

Much of the area surrounding the garden had been laid with red brick; although the brick itself was old and lovely, it was too dark, and reluctantly I took much of it out. Fortunately, I was able to find a use for the discarded bricks in the smaller paths that lead from the garden to the main house and guest house. Pale, blond flagstone, quarried locally, was installed around and right up to the edge of the pool.

Above: A pink nightstand with deeper pink flowers.

gardening

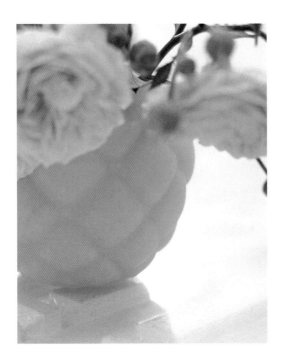

Above: A quilted glass vase. Painted pink on the inside to give dull color.

Opposite: My favorite task of the week: in my garden on Wednesday mornings. My vases and flowers are assembled before I begin arranging.

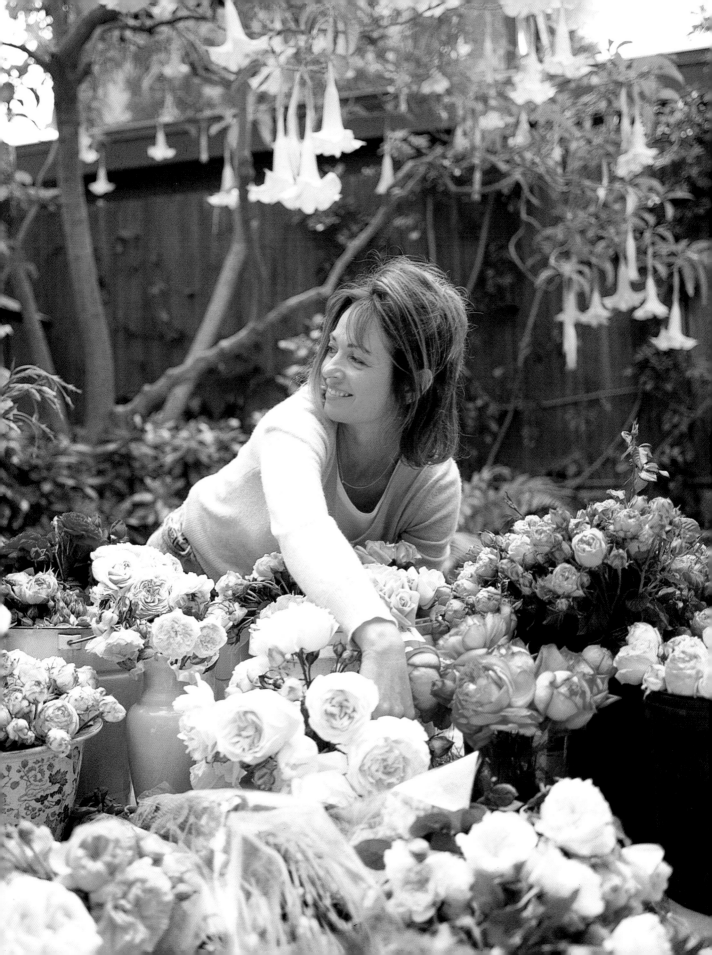

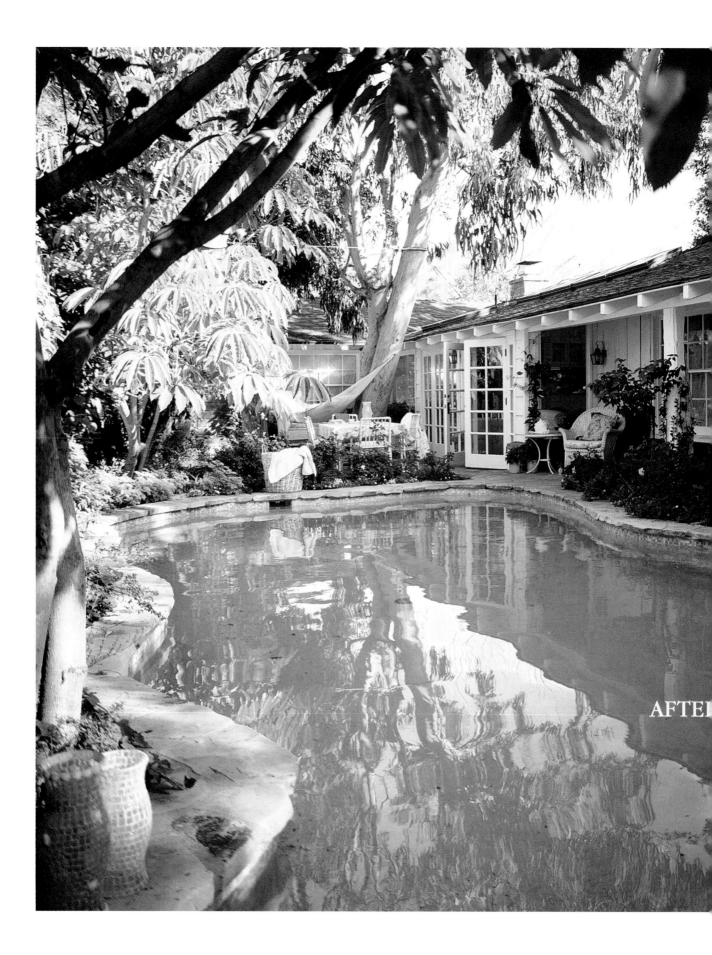

AFTER

The Pool

The pool itself was full of dirty, stagnant water, which had to be drained. Then a team of men—dozens of them, it seemed—chipped away the old and damaged black plaster. It took forever, but finally they were done, and then it was replastered. I chose my own mix of Italian glass mosaic tiles for the border. The finished pool became a big, bright oasis of turquoise right in the middle of the grounds. There is no getting away from its influence, and the color has even begun to creep into the house—I now have in the living room an exquisite chandelier with turquoise drops as well.

Moving the brick, laying the flagstones, and renovating the pool were long, hard, labor-intensive tasks. But it is worth mentioning that this is not a horror story: I had good workmen, I knew what I wanted, and they knew what they were doing. Kevin, my contractor, says, "You don't change your mind much, do you?" That is one of the ways I keep my costs down.

I also save time and money by applying two other simple rules: A quick decision is not necessarily the least good one; and it is not necessary to look at all 5,001 available choices before deciding. If I like the first choice well enough, I take it.

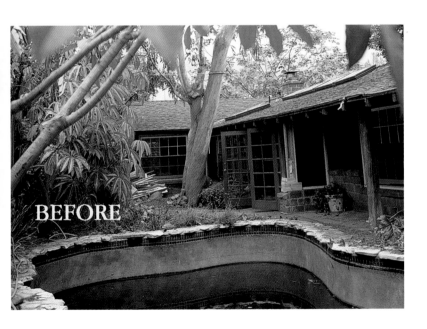

BEFORE

Opposite: I replaced the brick surround of the pool. Although the brick was great, it was too dark. Blond flagstone gave the area around the pool new life. I also replaced the large dark blue Spanish tiles in the pool and spa with small pale blue, turquoise, and pale pink Italian glass tiles. The pool and spa had been lined with black cement, which had to be chipped away before it could be re-cemented. Since the whole house looks out onto it, I wanted the pool to be light.

My Bathroom

When you start to redo a house you immediately become the recipient of plenty of advice, most of it bad. In no area of the house was it so generously offered as in the renovation of my bathroom. My bathroom adjoins my bedroom, so there was a general feeling that it should become more dramatically en suite, that I should rip down walls and build a big, glamorous bathroom, with a separate bath and shower stall, and plenty of closet space. And while I was about it, I should move either the basin or the window, since it was apparently out of the question to have a bathroom with no looking glass over the basin.

This was not what I wanted. I have always dreamed of a pure white bathroom—a *small* pure white tiled bathroom. There are many kinds of subway tiles, which are used in tunnels and are rectangular rather than square; I wanted the ones with the most authentic feel. I paid a little bit extra for some with a nice glaze, with small irregularities in the white dye and in the cutting. They have a handmade feel. The floor tiles are hexagonal and matte white; they come on sheets, each tile about one inch square. I had them installed without a border.

Above: I like the elegance of porcelain, and although the before door handle was the original, I exchanged it for a porcelain handle I liked even better. I was lucky to find enough matching door handles for the whole house. It is unusual to find so many of the same kind, but it's nothing to get hung up on—mix and match a little.

Opposite: The redone bathroom has the look and feel of a renovated bathroom rather than a remodeled one. This is accomplished by using materials and pieces that aren't too slick. The hexagonal floor tile has a matte finish, and the subway wall tile has subtly irregular edges. The bath is simple and has no fussy details. There are no built-in cabinets here and the bathroom is narrow, so the shallow chest-of-drawers is a must. It has to hold all toiletries.

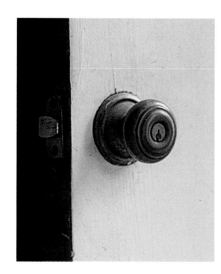

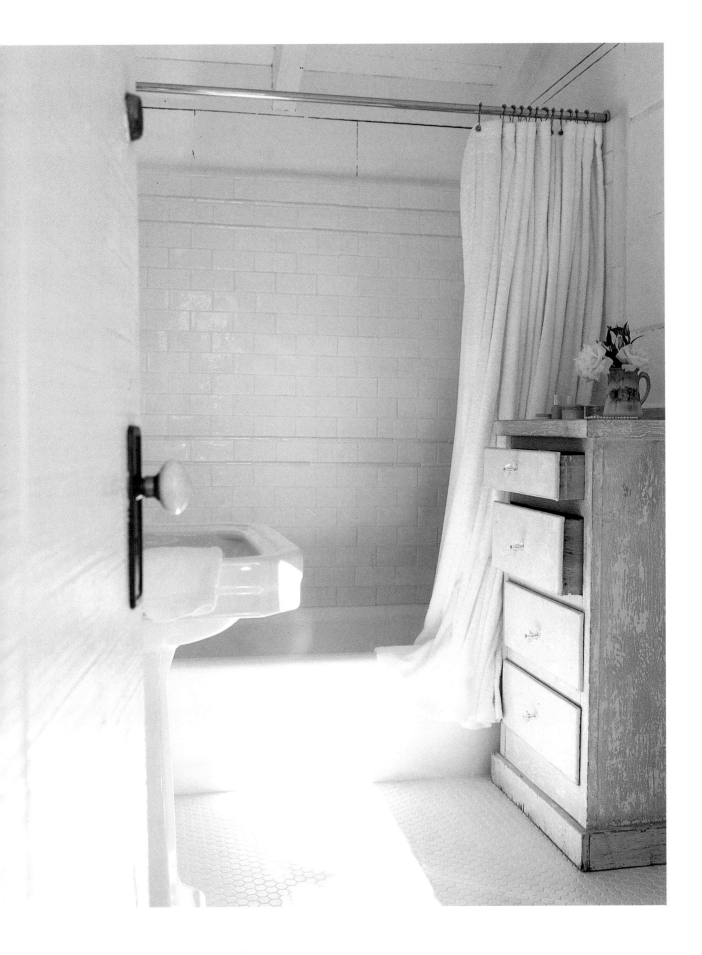

terry
s...

linen roll-up shade

use mirrors
to add light

mix old and
new towel bars

subway tile
half-way down
below dado rail wall

Deborah G '99

simple white, cotton
rug

MASTE...

~~r~~ curtain

Install bath

mirrors to be
varied in shape

look for
ways to
make up for
no built-in
storage space
e.g. roomy chest

replace
toilet

BATHROOM

white
hexagonal floor tile
(see detail)

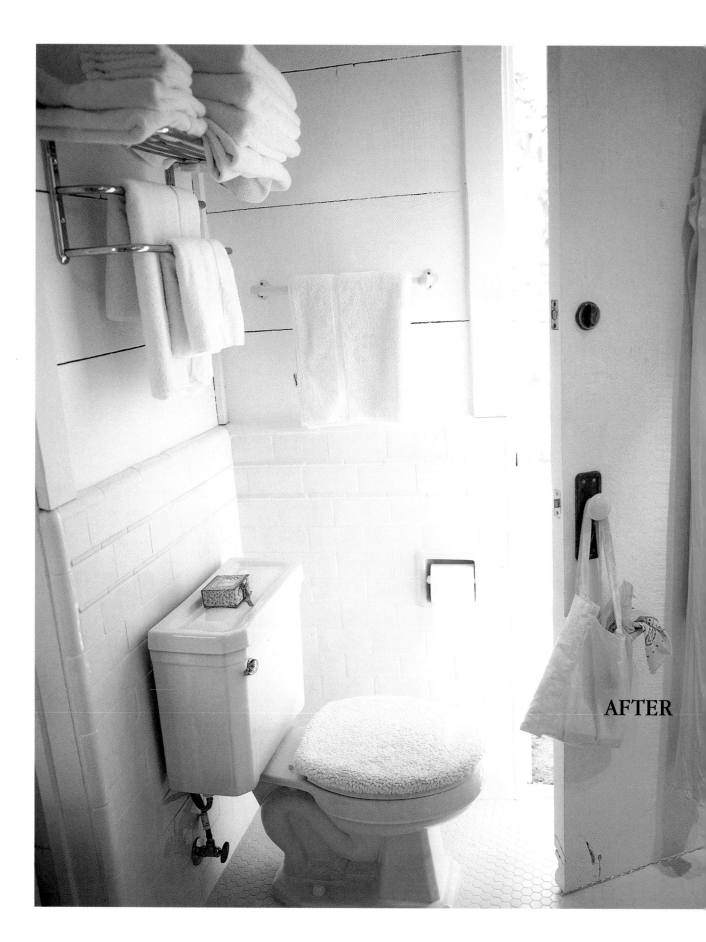

AFTER

accessories

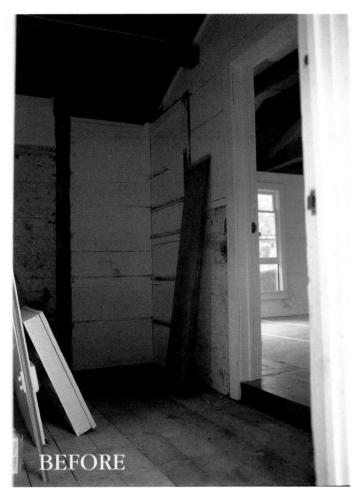

BEFORE

The other decisions I made about my bathroom were equally simple, equally willful. I kept within the four walls that I had inherited. Instead of moving the basin or the window, I installed a makeup mirror on an arm. There are two other looking glasses in the bathroom, one large and plain, the other pretty, but both useful.

I spent some time on bathroom accessories—toilet-roll holders, towel racks, hooks for bathrobes and nightgowns. Hooks and racks were very important, since there was no closet or cupboard for the abundance of soaps and towels that I like to be visible—I don't want them stuffed in a linen cupboard outside the room.

Above: We gutted the bathroom next to my bedroom

Opposite: My trademark luxurious white towel stack, mixing old porcelain and functional repro chrome racks. Again, since there is no cupboard space, stacking is a must.

For these accessories and the fixtures (toilet, bath, basin) as well as the hardware (faucets, racks, hooks), I chose a combination of the authentic originals and the new made-after-classics designs. I bought from several sources: authentic items at Liz's Hardware and classic household reproductions from Restoration Hardware (see Resource Guide). The toilet-roll and soap holders came from the tile shop, since they were a classic design in white tile. If you are starting a bathroom from scratch and you have the luxury, it is well worth creating recesses to house these fixtures. And if, as I was, you are working with a small space, each and every one of those inches that jut out into the room make a difference, so if you can inset these fixtures, it does help quite a bit.

I gave a lot of time and thought to getting the bath, basin, and toilet right. I had only five and a half feet in which to fit the bath—a small space by American standards, but I wanted to work with what I had. I bought the simplest white porcelain bath, and added a six-dollar chrome rod and a terry-cloth shower curtain. The toilet, a good plain design, came from my local plumbing store.

Above: The overflow of beauty products on glazed subway-style tile. Without being too rigid, I try to buy products that fit my color palette. Always flowers in unexpected spaces.

Opposite: These three lovely turquoise glass pots with lids—I bought them at different times—are handy containers for bathroomy things. Among all the sterile white, accessories are an important source of color.

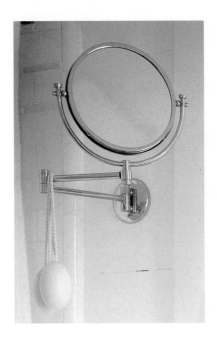

The basin took a little more time. For a moment I even considered building a vanity and dropping a basin into it, for a little surface and storage space. But what I really wanted was what I think of as a New York hotel sink: big and simple. Then I went so far as to take an old sink on approval from a salvage store, but it seemed too tedious to restore and rid it of its old stains. Also, a mixer spout—with both the hot and cold water in one stream—is one of the contemporary luxuries I rather like, so I decided on a new but classic design for the basin itself. For the taps it was a little—but only a *little*—more complicated. My plumber combined authentic porcelain taps with modern plumbing fittings. (I did have to work through my aesthetic needs with the plumber, but now I understand he has started to inflict my neuroses on his other clients.)

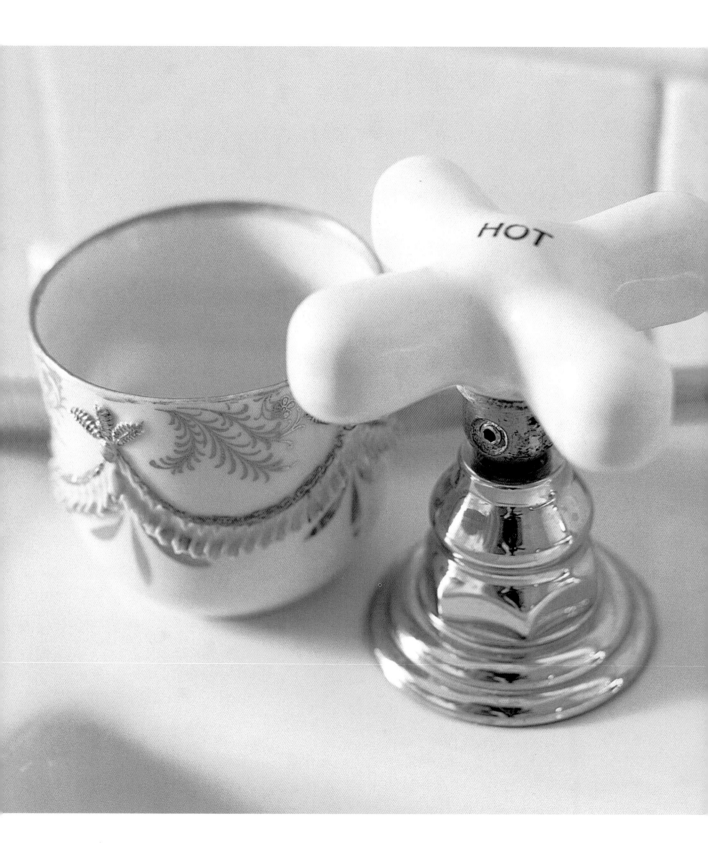

PLUMBING

Things to remember when renovating plumbing:

- Be open to mixing old and new. Combining the outward and visible part of an old faucet with a new and efficient plumbing fitting is not a big deal. You can, of course, use the old plumbing fixture that matches your faucet, but why take the chance when new plumbing is more reliable, and it's really only the taps that need to be aesthetically pleasing?

- Old fixtures can be found at salvage companies and flea markets. There is a wonderful choice of lettering and design: sometimes the whole faucet is porcelain, sometimes only the little plate that labels it hot or cold (if you buy French porcelain, remember that C is for chaud, which means hot, not cold!). To find a salvage company, look in the Yellow Pages or telephone your Chamber of Commerce.

- You will also need a soldering company, which your plumber can probably recommend, to solder the faucet handle to the new fixture. Even when this has been done you may need an Allen key to tighten the handle every few months. This is the kind of chore I don't resent—it's well worth the bother. I like to do little things around my house, for my house.

The cost of renovating my bathroom simply, but exactly how I wanted it, was not great by today's standards. It came within the ten thousand dollars I had budgeted for it. The tiles cost three thousand, and all together the bath, basin, and toilet cost fifteen hundred; the remainder was spent on labor and bits and pieces.

Above: Good soap, a luxury I don't scrimp on, in a simple scallop shell.

Opposite: My plumber came to understand my aesthetics. The base of the faucet is new, but we removed the slick handles and replaced them with old taps. This way we got functional new plumbing without losing the beauty of the old handles.

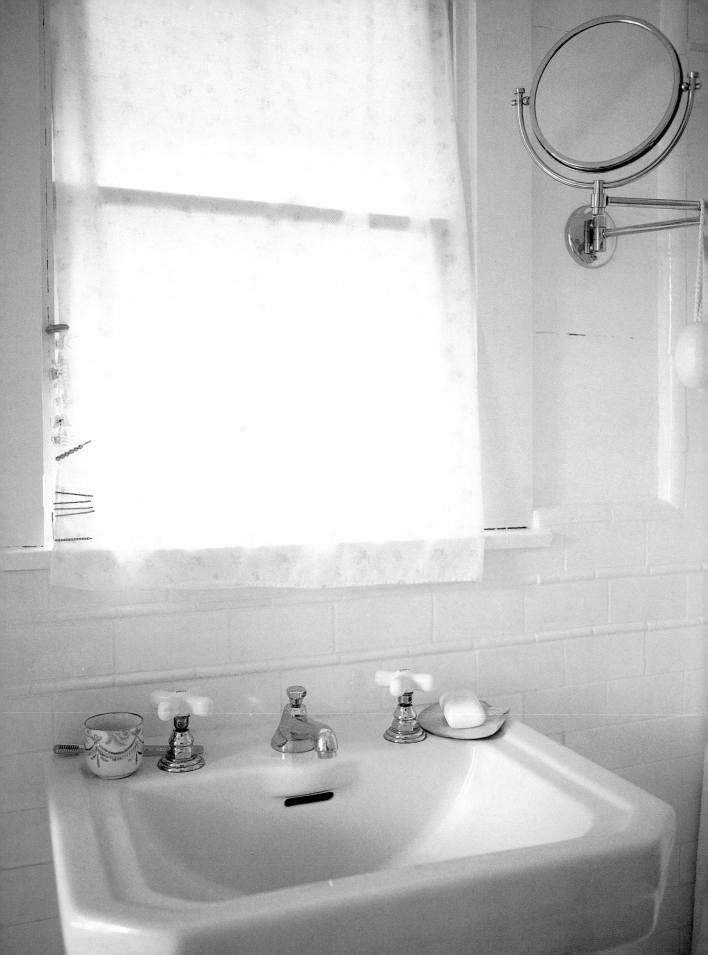

Above: Practical looking glass. No frills.

Opposite: I'm perfectly happy without a full mirror over my sink. A makeup mirror with a swivel arm does the job. The tablecloth caught in the top of the window acts as a curtain. Another temporary fix that became permanent.

Above: Hair clips. A functional place to keep them and totally decorative.

Opposite: Even though original baths and basins have a feel that can never quite be duplicated in reproduction pieces, there are some wonderful solutions. I did find an old sink and bath that I loved, but they both had yucky stains. Although these can be removed by having them re-enameled or recast, these procedures are expensive, and it's a huge effort to lug these incredibly heavy items around town. So I ended up with this very simple reproduction sink. Be careful not to be seduced into a fancier one—there is a danger of it looking too "reproduction."

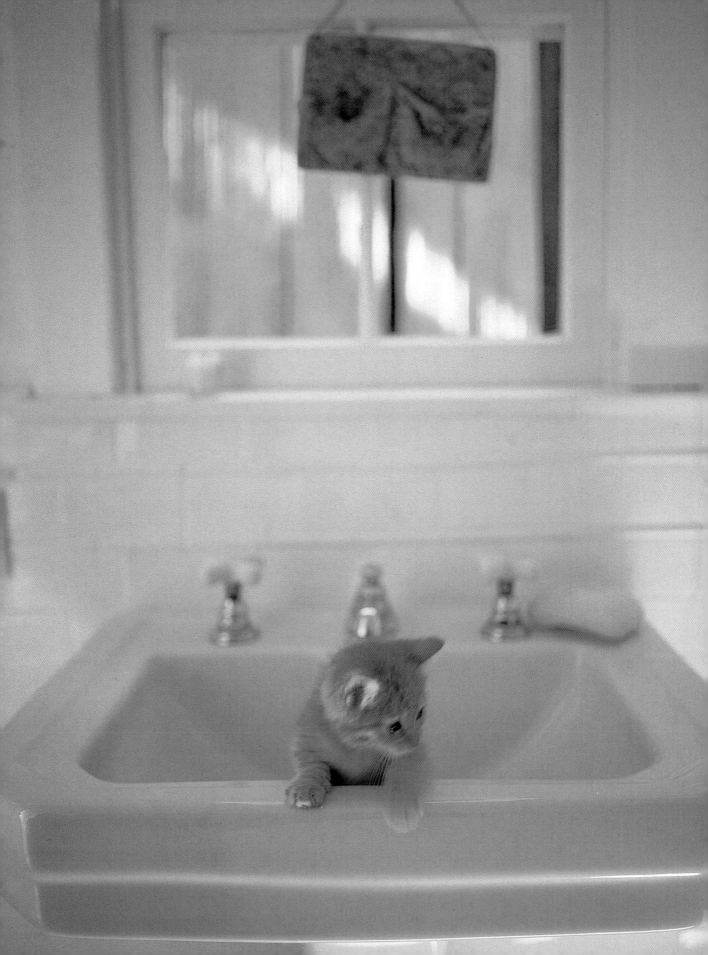

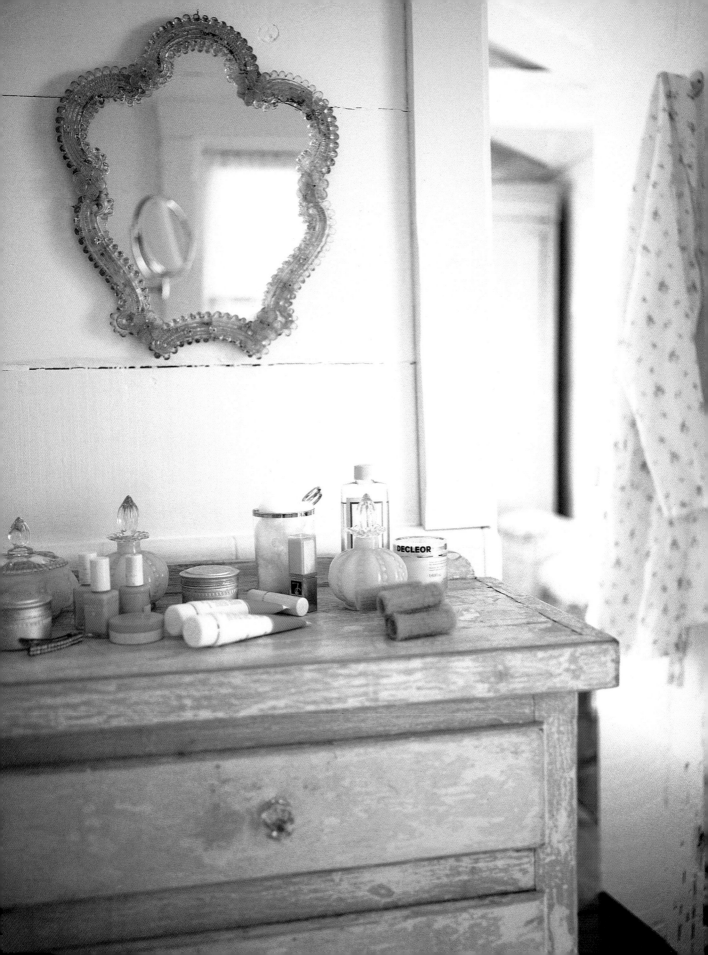

Without being compulsive about it, I try to choose cosmetics (they sit under a Murano looking glass on the narrow chest-of-drawers that used to be in Lily's room) and everyday utilitarian bathroom products in colors that will look good in my all-white bathroom. I always place small vases of flowers on the chest-of-drawers and by the basin. The hard, white surface of the bathroom is softened by the tablecloth that in a moment of belated modesty I used as an interim curtain, sticking it between the sashes of the window. It worked so well that it still hangs there.

One of the luxuries I enjoy is a fresh bath mat on the floor, and I like to change mine twice a day. So I have to allow for a large supply of mats on the rack and, of course, for a large hamper.

I kept the lighting that came with the bathroom—basic track lighting with big cans, but I changed the cans to small ones with halogen bulbs and added a dimmer switch. There are, of course, plenty of candles.

Opposite: My fancy Italian Murano looking glass, one of three mirrors in this small space, all with different uses and looks. The rustic chest-of-drawers was once used to hold the dollhouse in Lily's bedroom (you can see it in my previous book, *Rachel Ashwell's Shabby Chic Treasure Hunting and Decorating Guide*).

My Bedroom

There is a little step between my bathroom and my bedroom. The house has many little steps, most of them between rooms, and initially my contractor and (for far longer) the advice-givers thought I should get rid of most of them and level off the house in some way, to smooth the transitions between rooms. But I like my steps, and think one should guard against smoothing the character out of a house. I don't want to take any of the life out of my life with unnecessary smoothing-out or the impersonal qualities of technology. There are several time- and energy-saving devices—an intercom, a more convenient outdoor lighting switch—for which I have chosen not to dip into my renovation budget; having to walk up a couple of steps or across the garden to open the front door do not seem like hardships to me. All our technological equipment is kept in the guest-house room we use for an office, and I don't have a television in my bedroom.

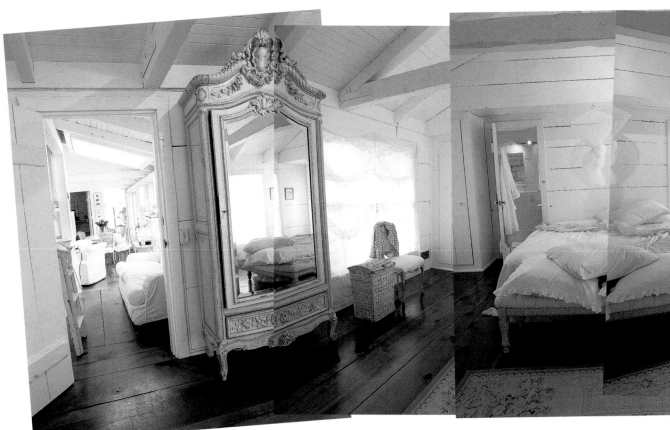

Below: The rumpled bed is complemented by the formal elegance of this French chair, with faded and dusty pink quilted upholstery and a worn gold-leaf carved frame—the Shabby and the Chic. The temporary curtain panel is simply thumbtacked onto the window frame; it was too long so I doubled over the top—no big deal. Whenever I think of putting up something more permanent, I can't visualize anything I would like better.

The soffit was built to cover the beam that is directly over my bed. My mother was concerned of the feng shui implications of having a beam over my head, afraid it would stifle my energy. The Chinese needlepoint copy of an Aubusson rug is lightweight and can be folded up like a throw when my daughter practices dance or when I have an exercise session.

I had this wardrobe built for me. There was no closet space in the room and I felt the French armoire needed to be the focus of attention, so I asked a carpenter to build something that would blend into the woodwork. I feel an open closet should be tidy and pleasing to the eye; a cluttered closet feels like a cluttered mind.

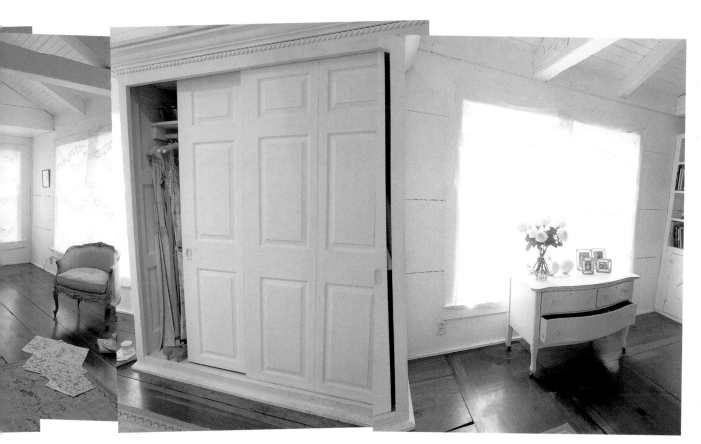

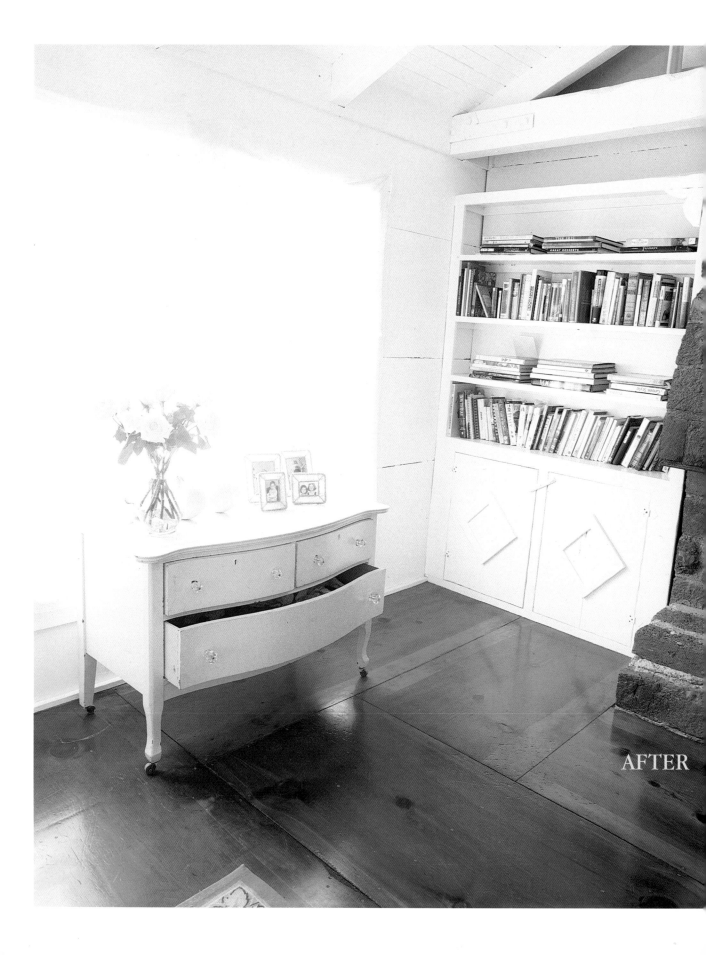

AFTER

My bedroom is the most important, and the most beautiful, room in my house; I love its four large windows and a huge brick-surrounded fireplace. I did very little to it. It has the magnificent old wide-planked wooden floors that are throughout the house, and it is, of course, painted entirely white.

Again, I left the existing track lighting, as well as the irregularly carved shelves (leftovers from the *Hansel and Gretel* days) by the fireplace. Neither would I have chosen, but neither poses something I can't live with. Both became reasonable compromises: I have a dimmer switch for the track lighting and a small lamp by my bed, as well as my candles; a couple coats of white paint did wonders for the shelves.

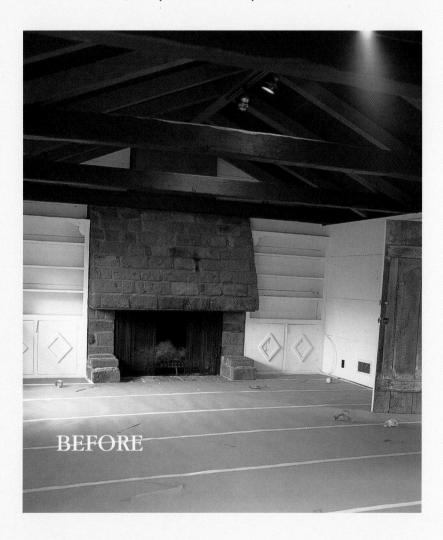

BEFORE

A corner of the bedroom, before and after. I thought that painting the chimney white would be too much, so it remained red brick. The dark wood was porous and needed layers and layers of paint.

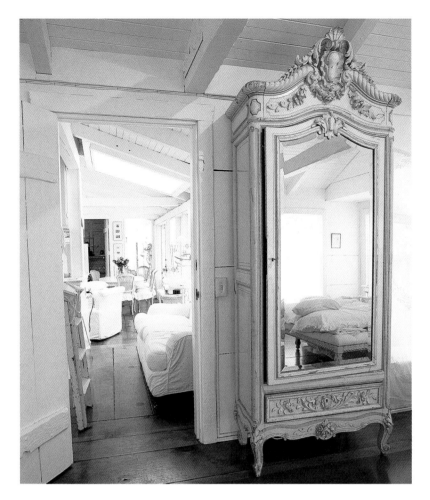

I disregarded the suggestions that I should have a walk-in closet. The room is certainly big enough, but I much preferred the creamy, delicately carved armoire I found on a shopping-and-searching trip to Summerland, in Southern California. I use it for sweaters and assorted clothing, and it also houses my sound system—there is even a convenient drawer for CDs. I guiltily had to cut off the back for the stereo equipment to fit.

There is enough space in my bedroom for two fancy armoires, but this is one of the many examples of less being more. Instead, for approximately the same amount of money, I had a wardrobe made to order, so plain that it melts away into the white wall.

Above: The ornate French armoire houses bulky sweaters and stereo equipment. This is a typical example of how important it is to know your measurements: the crown molding of the armoire just fits under the beams of the ceiling. I like the contrast between the grandeur of this regal piece and the plain beamed ceiling.

Opposite: A quiet work area. I am careful not to bring work into my room, but some floral artwork pages are allowed.

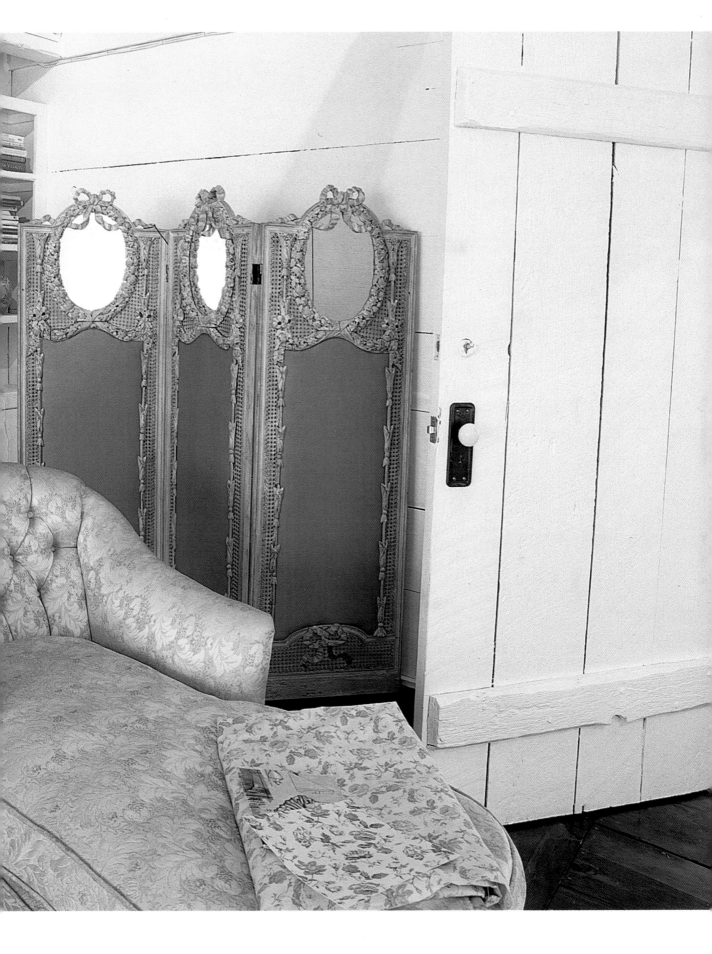

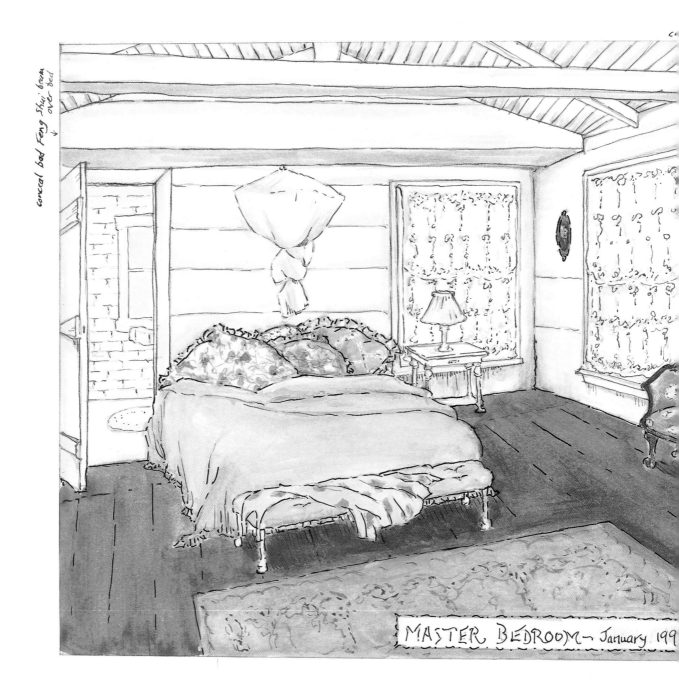

conceal bad Feng Shui beam over bed ↓

MASTER BEDROOM — January 199

upholstered - or slip-covered as alternative

built-in wardrobe with sliding - not open out - doors

keep original stain on floor

Deborah G. 99

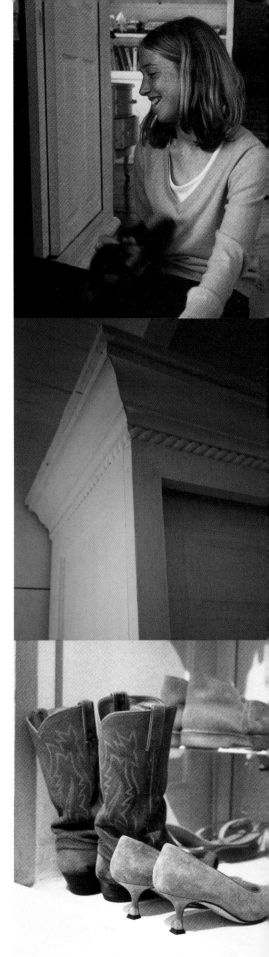

Top right: Lily, telling me something very important.

Middle right: We added a subtle rope trim to give the wardrobe a little definition.

Right: I can't bear cluttered closets. If my shoes are messy, it's probably time to get rid of some.

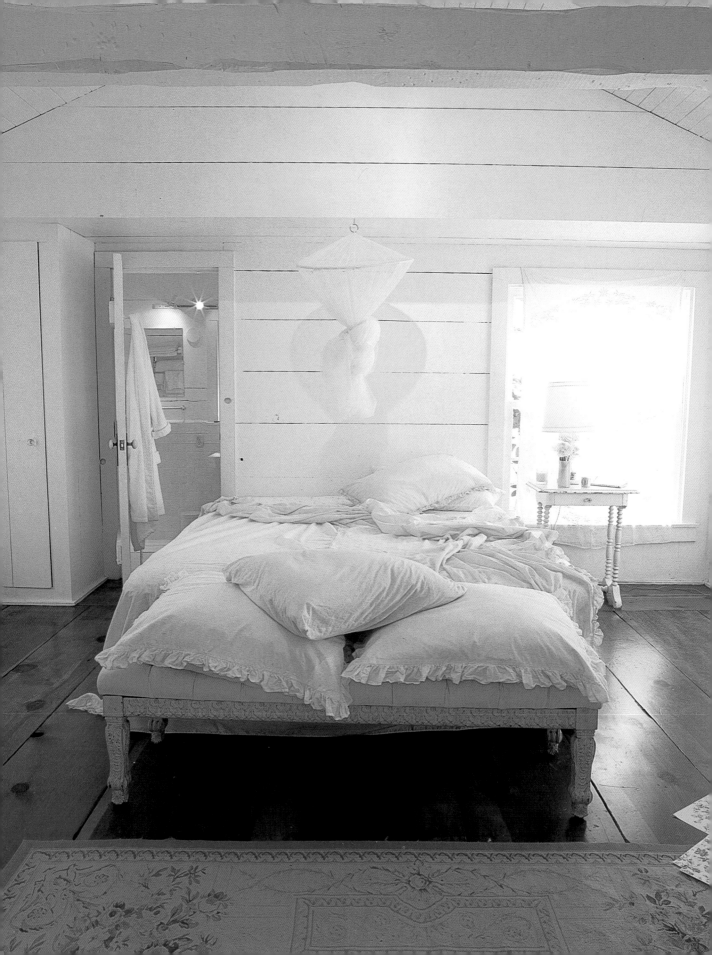

comfort

My bedroom is the largest room in the house, with the most floor space, and for a smaller family would probably be the living room. But with only two other bedrooms, for my children, I need this space as my own room. I looked for a carpet large enough to fill the space but lightweight enough to be easily moved, since the floor is the logical place for me to exercise and for my daughter to do her dance practice.

My bed is the central point of the room. I have no headboard, but lots of pillows and an absolutely necessary mosquito net suspended overhead. One way or another, the bed is home for a lot of fabric. So I added a small, elegant pink chair by the window, whose fine-lined delicacy balances the soft casualness of the bed. The windows are covered with lace panels, again held in place with thumbtacks; there is not a rod, pole, or curtain ring in the whole room. The white walls are bare except for my "Humility" plaque, about priorities, which was featured in my previous book.

No headboard—I like the simplicity. The mosquito net is vital, but even if it weren't, I love how it looks, open and closed. On a warm day even a duvet or comforter is not necessary. A simple gauzy sheet is pretty and throwaway-chic enough that the bed, even unmade, looks fresh and inviting.

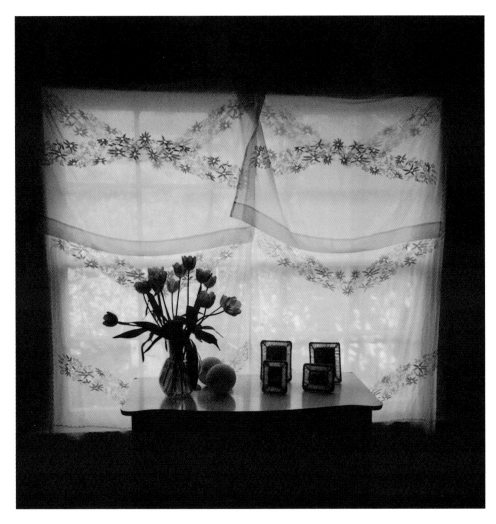

Above: Black-and-white shows clearly how much lovelier less can be. Beautiful textures.

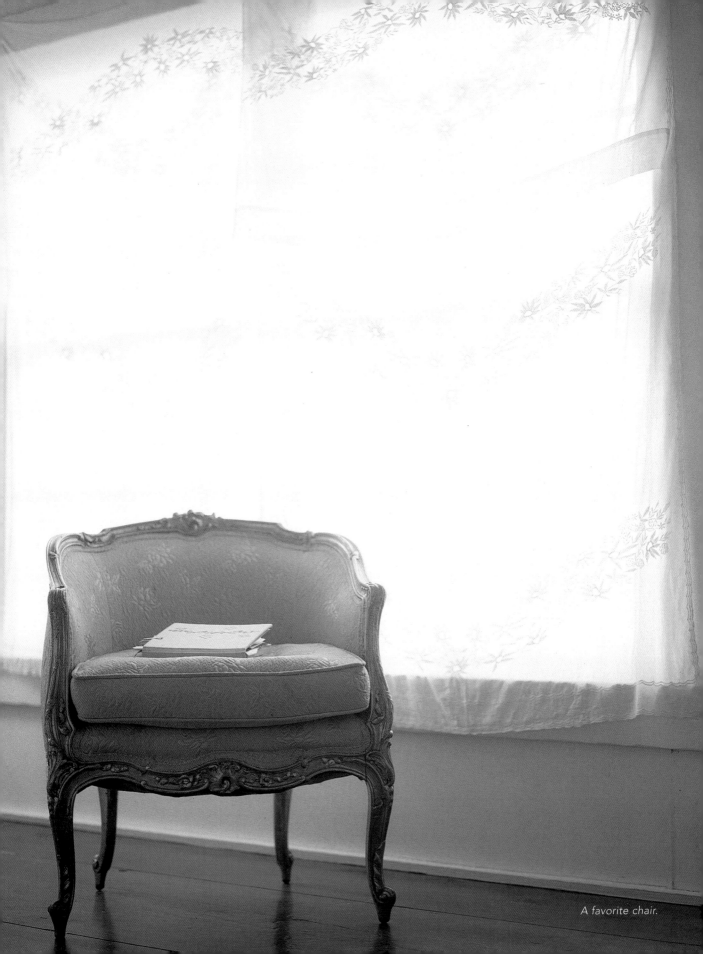

A favorite chair.

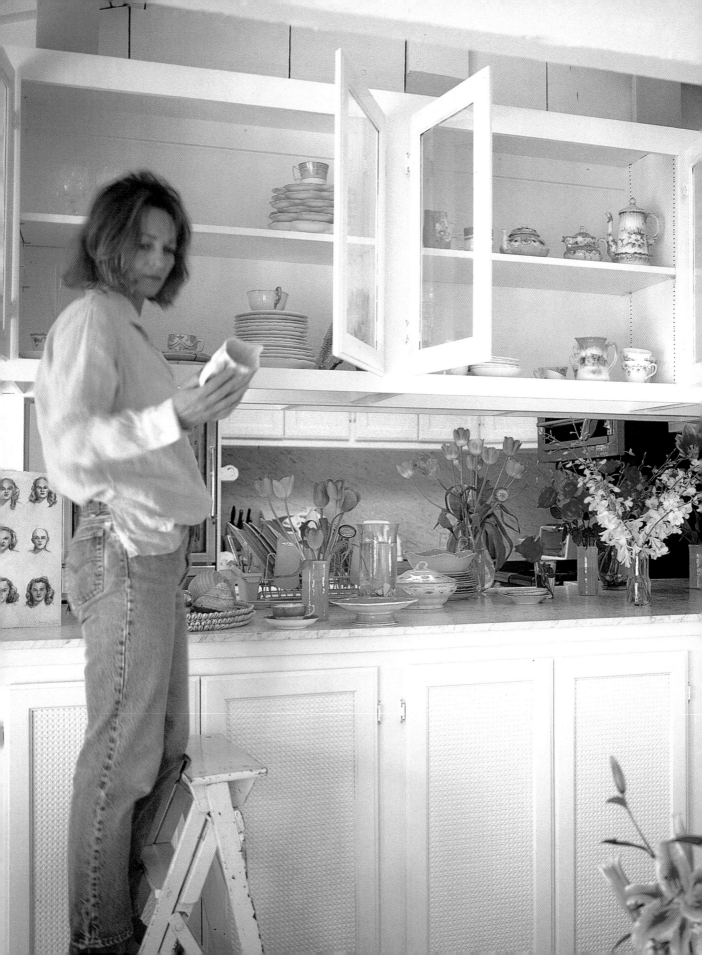

The Kitchen

The kitchen is next to the bedroom. Almost too convenient, since at night I can hear the hum and purr from my beautiful glass-front refrigerator. The refrigerator and stove came with the house, and I treasure them. But they come at a price: the fridge is noisy, and the old-fashioned professional catering stove has an intermittently unreliable pilot light. I go back and forth in my mind about replacing them someday.

The kitchen, albeit small, is easy to work in. There is plenty of cupboard space, more than I really need, and that is a luxury. I painted the whole room white—the cabinets, ceiling, and even the overhead copper light-fitting. The food in the glass-front refrigerator provides most of the color in the kitchen. There is fluorescent lighting under all the cabinets, something I would not have put in myself, but since it's there I find it useful. The faucets and the sink I replaced—the simplest I could find.

I also replaced the brown granite slab counter with white-and-light-gray-veined marble. The marble was a major item in my budget: It was important to me to have a kitchen that was not only hygienic and easy to keep really clean but that I also enjoyed being in. I was very careful that the marble should not look too slick and chose a dull finish. There is not enough room in the kitchen to do a lot of anything decor-wise. And the fewer materials I used, the cleaner and smoother the room looked. I carried the marble up the

Opposite: The contents of these cabinets are part of the decoration for this living space.

wall to the cabinets' bottom, to make a splashboard. But again, this work was much more of a renovation than a remodel.

The kitchen is not only light and functional, but it is also part of the decor of the living room. I imagine that if the original intention of the house was for my bedroom to be the living room, then our present living room would be the dining room, which may explain why part of our living room wall is composed of the kitchen cabinets. The cabinets open into the kitchen and still have their original, slightly rippled handmade glass— the subtle imperfections are striking and charming, and they are always among the first details my guests notice. The china I keep in them is an important part of the balance of color in the room. Below the marble counter, the wood-frame cupboards have wicker inlays, which were rattan-colored but are now washed in the same white as the cabinets. I was very lucky to have found both storage areas in such serviceable condition: Replacing or even significantly renovating kitchen cabinets is a surprisingly serious endeavor—not one that should be taken lightly, nor one that can be accomplished inexpensively. Before deciding to rip out old cabinets and start afresh, consider altering the existing ones to suit your taste and needs.

I store my table linens in these lower cupboards, and it is always a pleasure for me to open the door and see my white and floral linens. They are not stacked formally or even always very tidily, but the result is always pretty. I try to make sure that any cupboard I open anywhere in the house gives me similar pleasure.

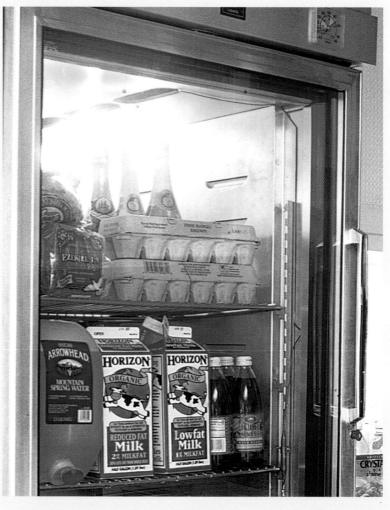

Love, love this fridge and the display of products, but I am thinking of replacing it, since, sadly, it is a little too noisy, being too close to my bedroom.

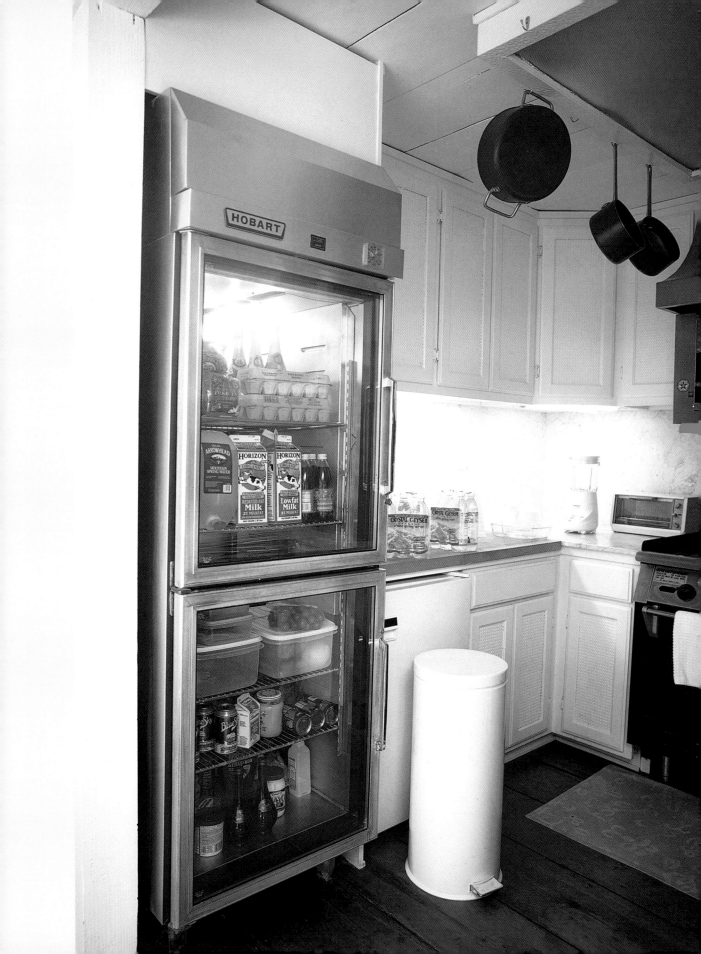

Above: Tweety. Bohemian color against the white.

Opposite: The kitchen. Everything, even the front of the dishwasher, is painted white. I added marble and new faucets. I like the industrial feel.

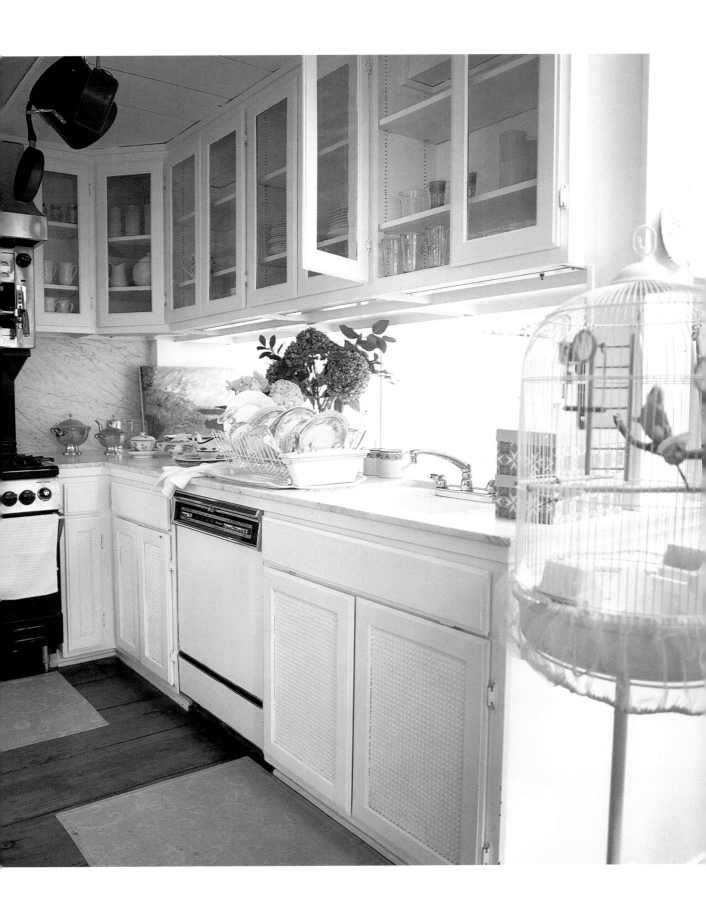

details

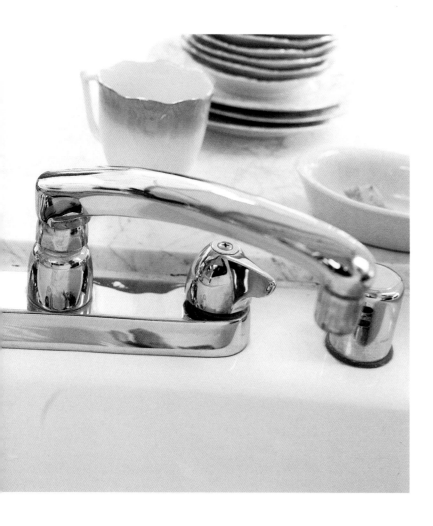

Above: Today's faucets—I can barely believe the choices. For me, however, once again classic and simple (which also happen to be the cheapest).

Opposite: Carrera marble honed to a blunt, straight edge, not bullnosed into a thick, rounded edge that gives the illusion of bulk. Many people today have shiny countertops that are a little too slick for my taste. Some warn that the porous nature of marble causes it to retain stains, especially if you remove the shiny surface. But I haven't had a problem.

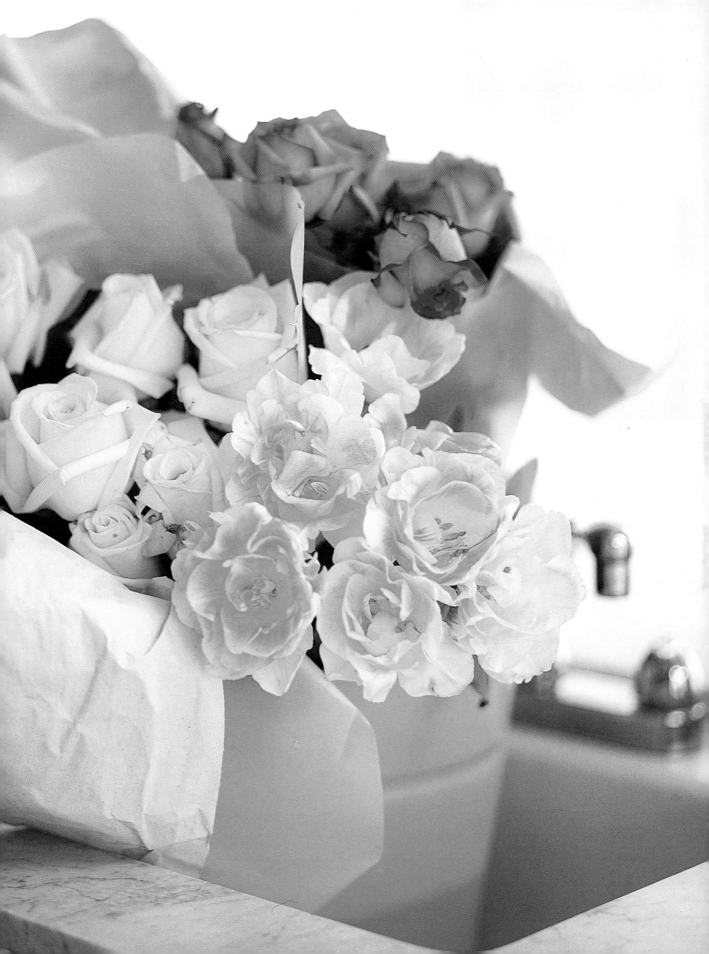

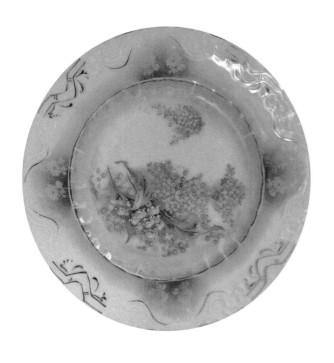

The beautiful rests on the foundations of the necessary.

—RALPH WALDO EMERSON

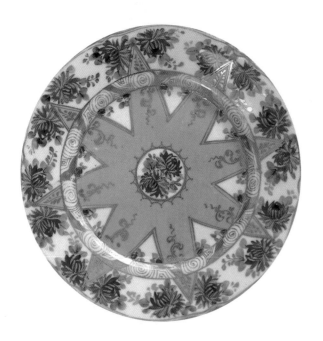

Above top: I like the way the central pattern slips under the rim to join the border pattern.

Above: An inviting cake plate.

Opposite: Even opening the dishwasher should be a joyful experience. All plates, cups, and saucers should be pieces you love to see. Mismatched is all right; ugly is not.

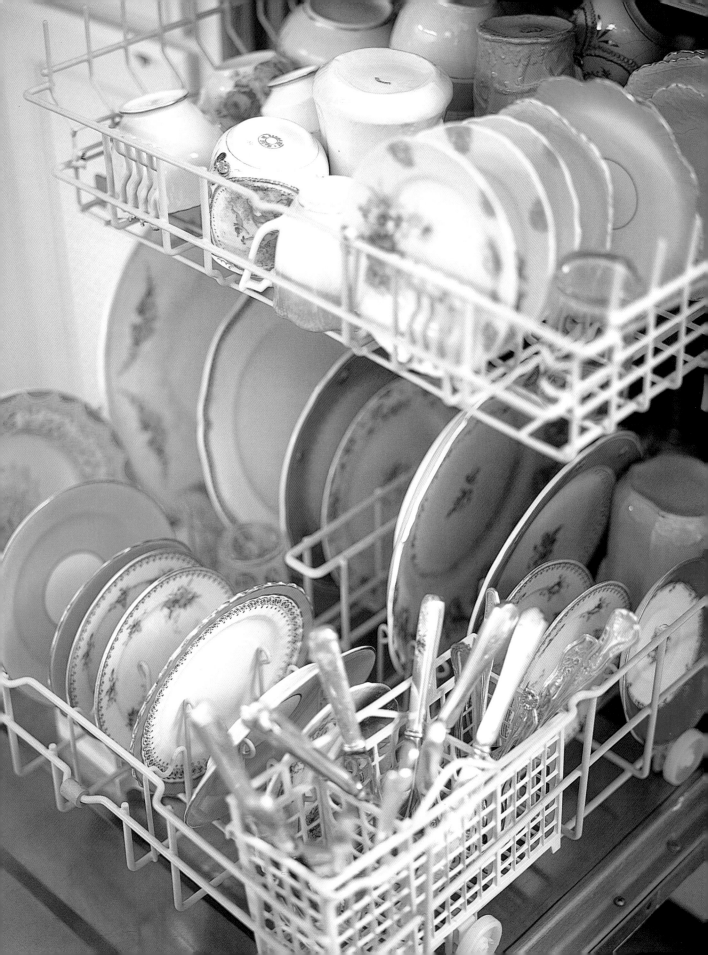

The Living Room & Dining Area

Every window in my house has a view, and one wall of my living room is entirely glass—windows, a French door, and the entrance door. The glass wall brings the colors of the pool and the garden into the house. The turquoise drops on the chandelier are the same color as the pool; before installing it, once I would have unpicked every turquoise drop and replaced it with clear glass, and I probably would have tried to do something about the gold paint as well. Now I leave it all as is, thanks to the colorful inspirations that surround me. The rest of the room is lit by sconces, lamps, and candles.

The living room is sparsely decorated: just a few paintings and some family photographs on the walls and propped around; the room depends on the outdoors for its decor. As the seasons change the flowers in the garden, I change my slipcovers in the living room. It is the best room in the world for a rainy day. And, of course, there are no curtains.

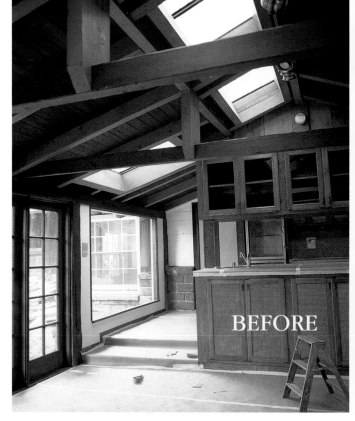

BEFORE

Above: The before living room. The wood was dark, dark, dark, and I was grateful for the skylights. A few wood lovers disapproved of painting natural wood white—oh, well!

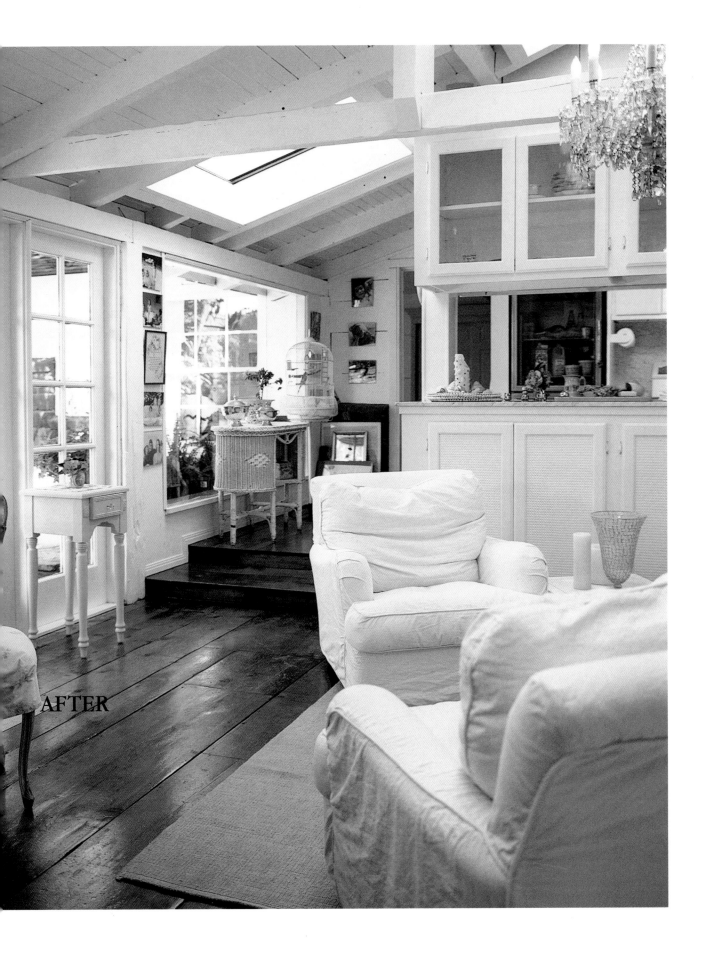

AFTER

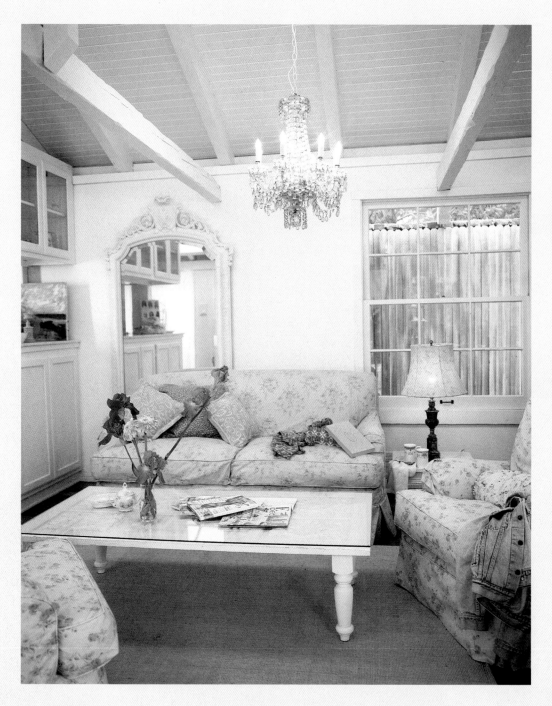

My spring slipcovers: a muted monochromatic teal floral pattern. With them, an unusual teal alabaster lamp. The slipcovers, the lamp, and the flowers can provide subtle but significant changes for the season.

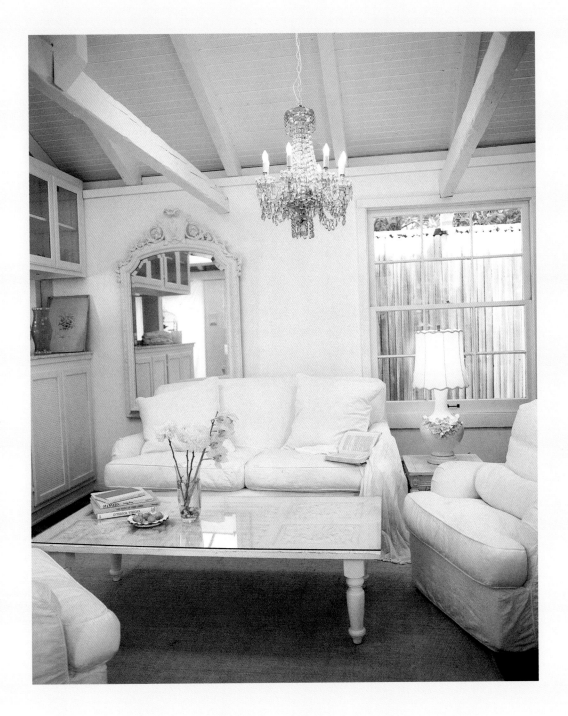

White linen slipcovers replaced the white denim I lived with for many years. My children are now old enough to handle the more sophisticated linen. My coffee table is an old oak door, painted white, which sits on inexpensive Home Depot turned wooden legs. A piece of glass creates a smooth surface over the carved top.

w h i m s y

Above: A detail of an old door we use as a table; I painted it and put glass on top.

Opposite: Twinkle whimsy. Once I would have taken the turquoise crystals off this chandelier before I installed it, but the color of their sparkle is a reflection of the swimming pool outside.

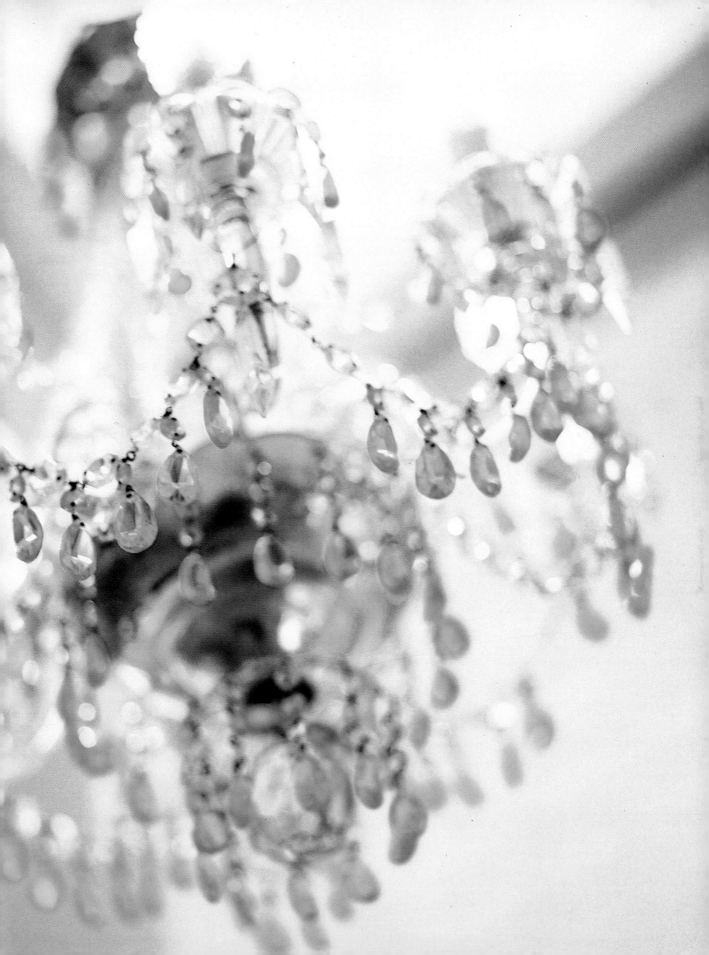

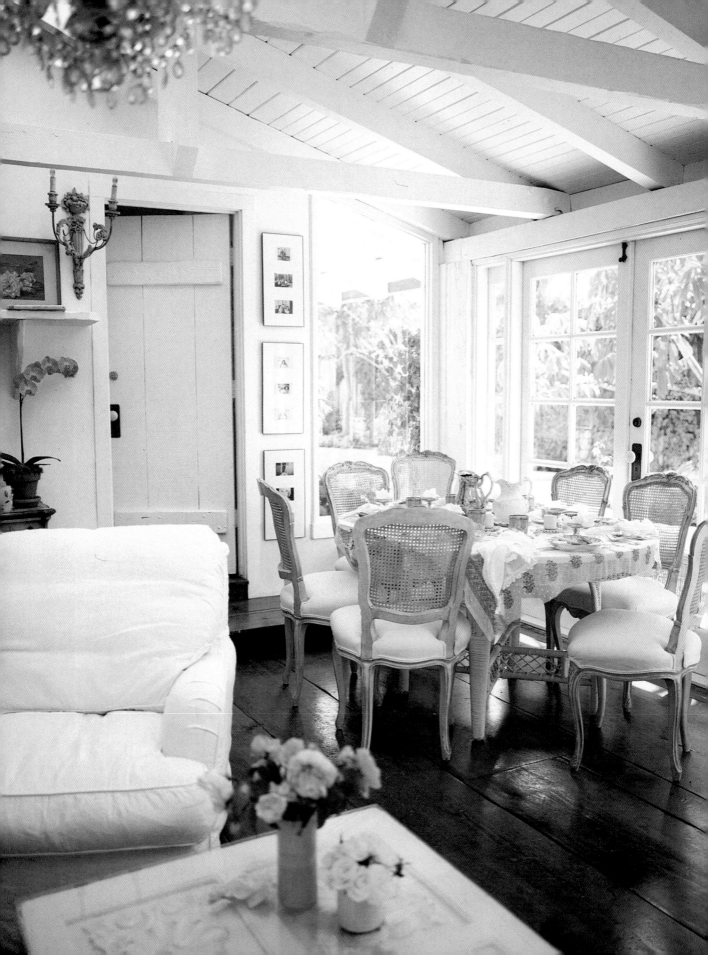

One of the few structural alterations I made to the house was to move the glass front door, exchanging places with a window—a day's work for the carpenter. This was necessary since the comparatively small living room not only is a throughway to my children's rooms but also doubles as a dining room, and the door had to be moved to make room for the dining table. Although if it is warm, most family dining and all entertaining take place outdoors. When we entertain in the garden, I open the French doors and push the table into the opening, so it becomes a two-sided buffet, indoors and outdoors.

Above: The white linen chair.

Opposite: Although this room is small, it holds a dining table and eight chairs. Placing the table here allows a view of the courtyard, swimming pool, and garden. During the summer months I open the French doors to create an inside-outside buffet.

The curtainless view of the garden is not the only instance of the immediacy of nature. Sometimes at night a convention of raccoons dances on the roof, and even more noisily on the skylights. The raccoons are far from bashful, and I warn my guests to keep the door of the guest house firmly shut unless they want to find a family of utterly cute but sharp-toothed and possibly rabid raccoons cuddled up beside them.

The beautiful wide-plank wooden floors in the living room—indeed, throughout the house—were a wonderful surprise, and in nearly perfect condition: The irregular-width planks weren't missing or damaged or loose, and I didn't have to pull up carpeting or linoleum (then scrape off glue, then sand, then stain, and then finish); I barely needed to apply a new coat of wax.

Similarly, the walls and ceilings gave me no trouble: no wallpaper to steam off, no sheetrocking or spackling to repair major cracks or holes, just coats and coats of white paint. There's no molding—this is much more of a cabin than a cottage—and so I avoided another potential headache. And although the beautiful sash windows were hard to open, they didn't need serious attention: I merely renewed the sashes to ease opening, and replaced the locks and screens for a uniform look. This was only a couple days' work, instead of the major overhaul (and huge expense) that old wood windows often demand.

Opposite: The teal floral chair from my living room.

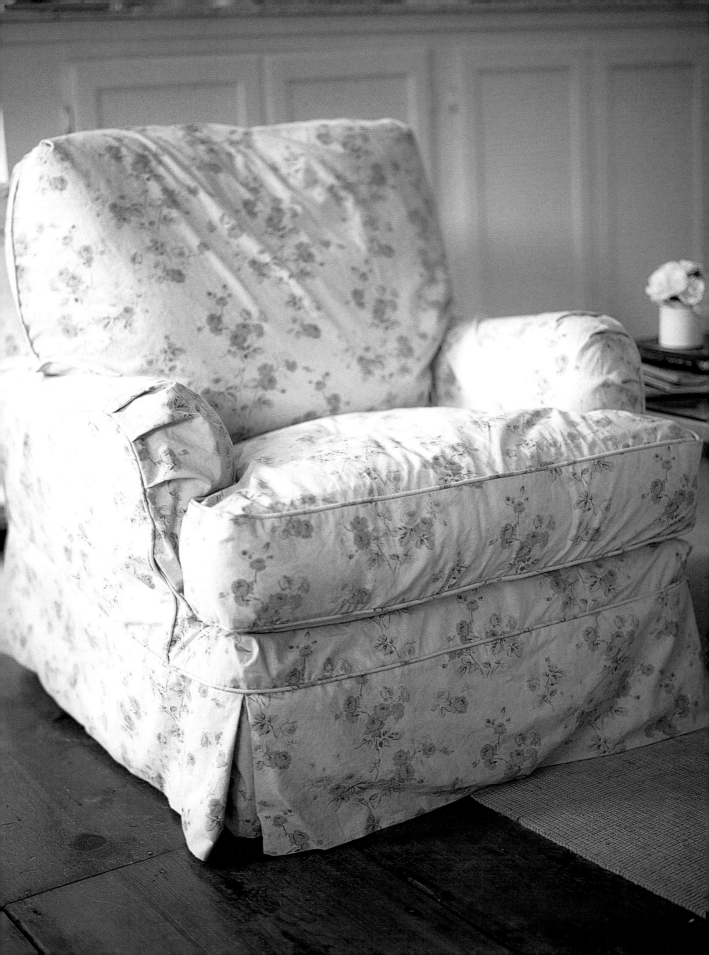

The Guest House

My guest house, minus the raccoons, is light, pretty, and multifunctional, and is built over the garage, which includes the laundry room and the infamous tunnel to the garden. One climbs a flight of exterior wooden stairs to a large, sunny deck, which is level with the upper branches of the surrounding bushes and trees—only the eucalyptus towers above. The deck is a lovely place for my guests to sit during the day, to enjoy the sun and breathe in the scent of the sweet-smelling angel's trumpets and jasmine; or at night, to look at the sky through the eucalyptus branches, pleasantly aware of the many sweet-smelling plants below.

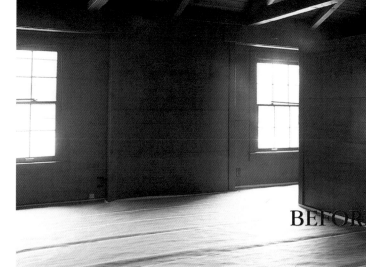

BEFORE

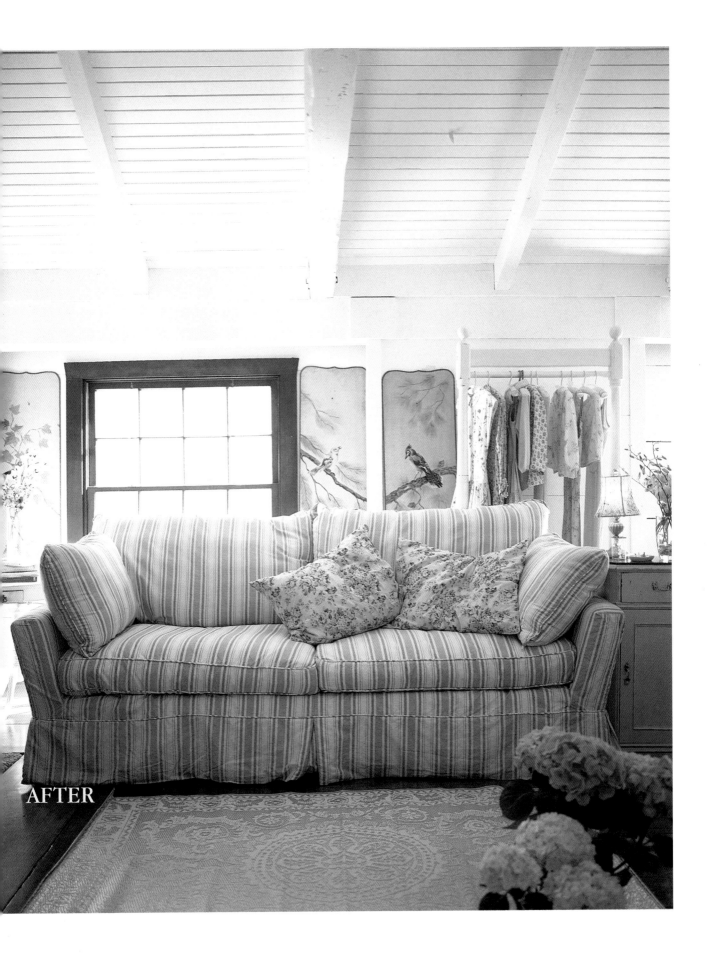

AFTER

function

When buying old light fixtures, always have wiring and plugs checked and replaced at a local lamp or lighting store. I get this type of white cording and plug instead of the standard dark brown plastic wire, a small detail that makes all the difference.

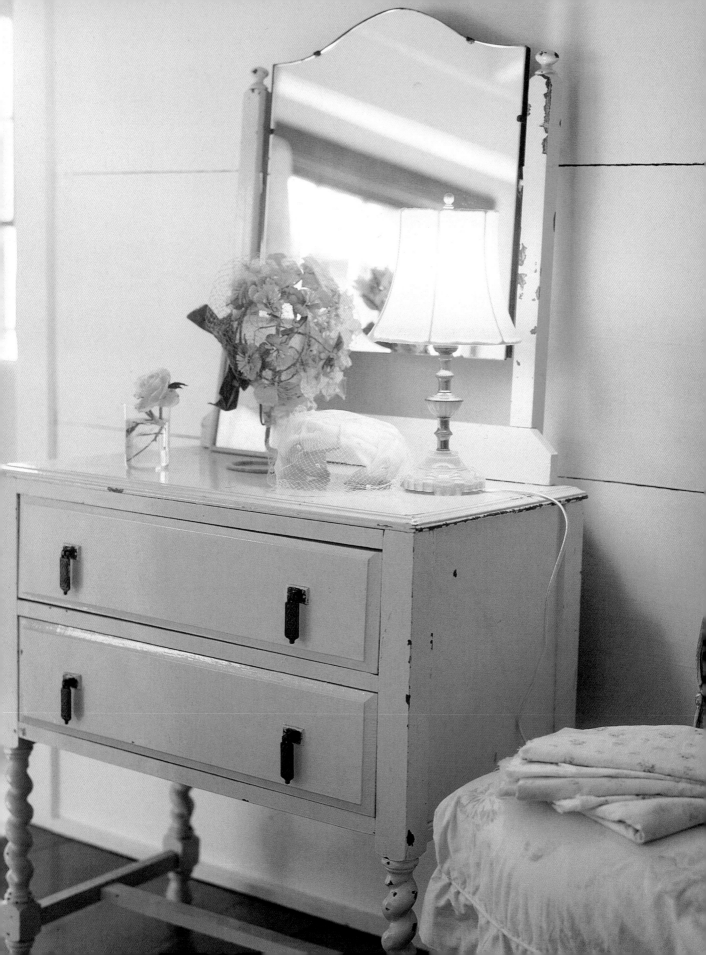

MAINTENANCE OF WOODEN FLOORS

I infinitely prefer a waxed floor to one sealed with polyurethane. A waxed floor takes a little more work but is more than worth it. Instead of that high-gloss nail-polish finish of polyurethane, the floor looks rich, beautiful, and will become even more lovely with age.

The care of polished floors is largely a matter of common sense:

- Mop up anything you spill right away, and don't allow potted plants to sit on the floor—their dripping water will stain and grain the wood.

- Use doormats to limit the incoming dirt, and don't allow grit to get tracked into the room.

- Vacuum regularly, and in between thorough cleanings, use a soft brush or dry mop to keep the floor shiny.

- Have the floors professionally waxed and buffed twice a year.

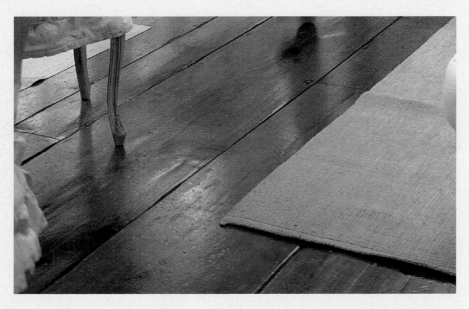

Opposite: Pink dresser with mirror. Usually I would replace the handles with glass, but in this case I felt the dark handles provided a little masculinity that echoes the darker floors.

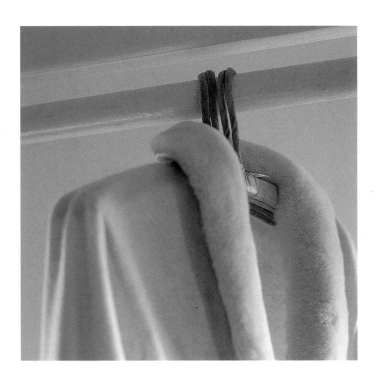

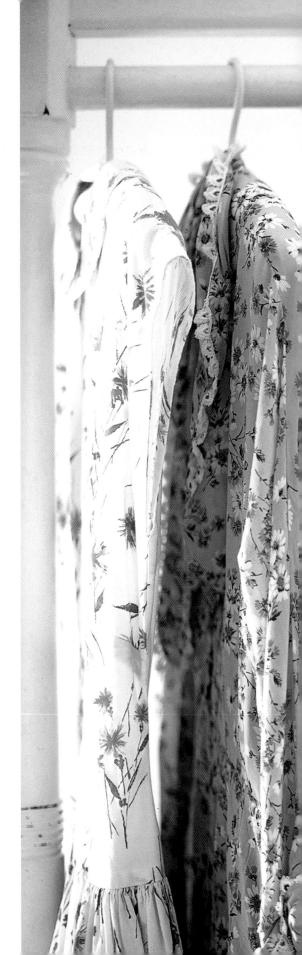

The guest house is well built—it too has good bones. It is solidly made of quality wood and has a fine brick fireplace in the bedroom. The outer room serves as an office, and the bedroom serves not only as a music room, but also, thanks to a super-comfortable sofa bed and a wardrobe rack (there are no closets in the guest house), as welcoming guest quarters. The floors are made of the same magnificent wood as the main house, and here too the wide-plank boards do not match in width. I am proud of how lovely and inviting the guest house is, especially since I made few changes, working with what came with the house. Although, as usual, I didn't stint on the white paint.

Above: A cashmere cardigan with a fake fur collar. It feels sumptuous. A set of four green velvet hangers tied with green silk ribbon. I always keep an eye open for pretty old hangers at flea markets, thrift shops, and garage sales.

Opposite: Lack closet space? A wardrobe rack can do the job. And if your clothes are of a focused and pretty palette and you choose yummy hangers, it can be decorative in itself.

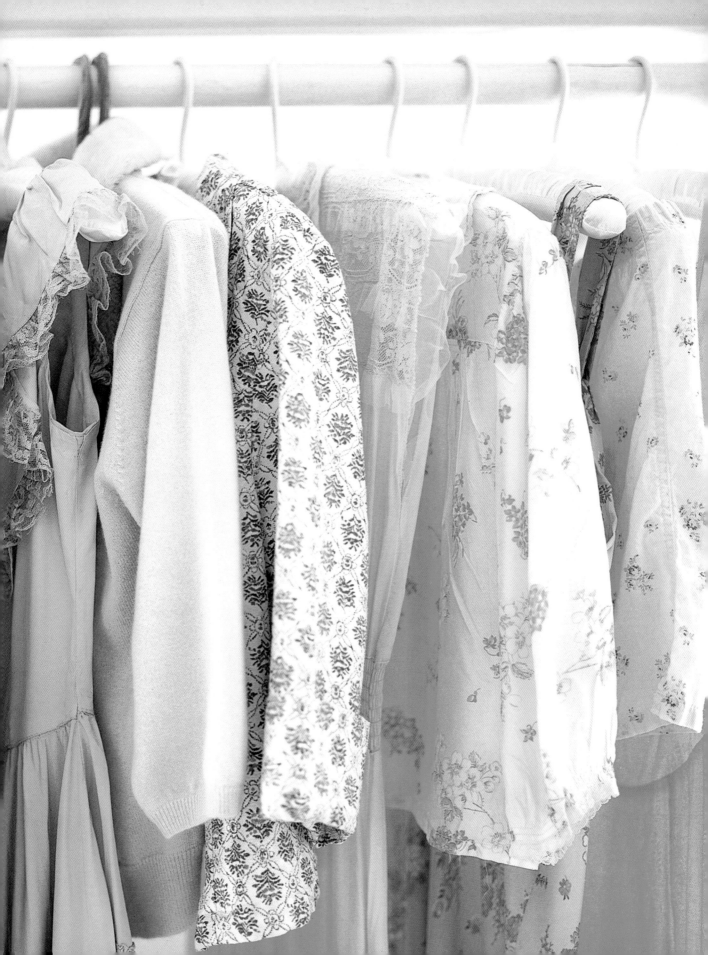

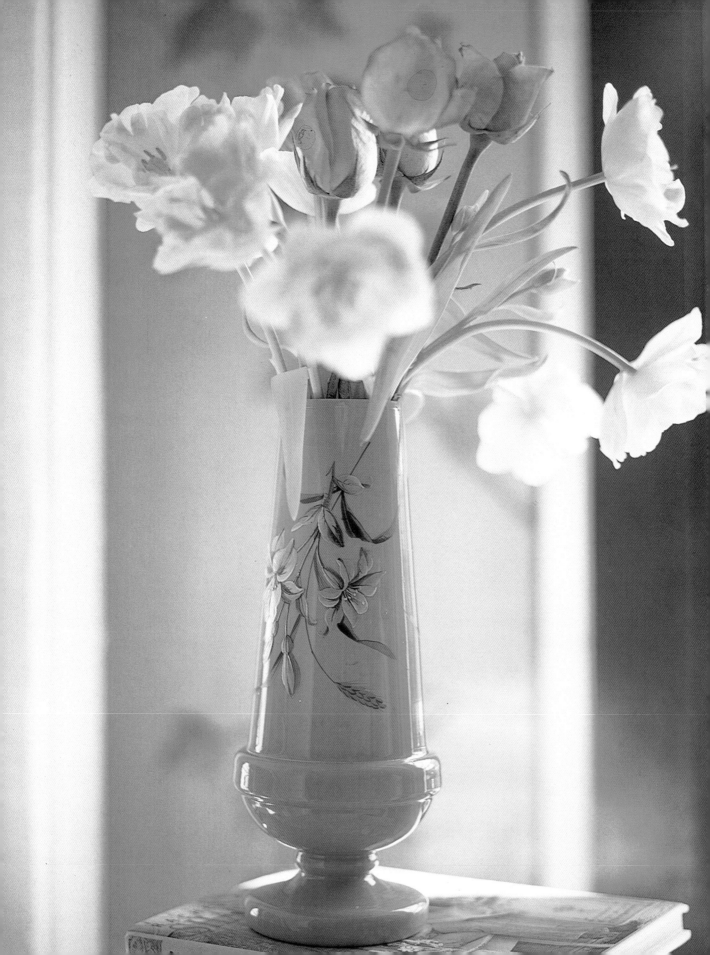

Things to consider when buying a house:

- Buy a house for what it is, so you can restore it, not remodel it.

- Don't be bullied by so-called experts.

- Don't feel you have to see 5,001 examples if you really like the first one.

- Having something custom-made sometimes doesn't cost more than buying it, especially if it is something with specific measurements or function—a piece for a narrow hallway, for example.

- Less is more. (One great armoire in my bedroom is better than two.)

Opposite: Shades of pink loosely arranged in a darker pink vase.

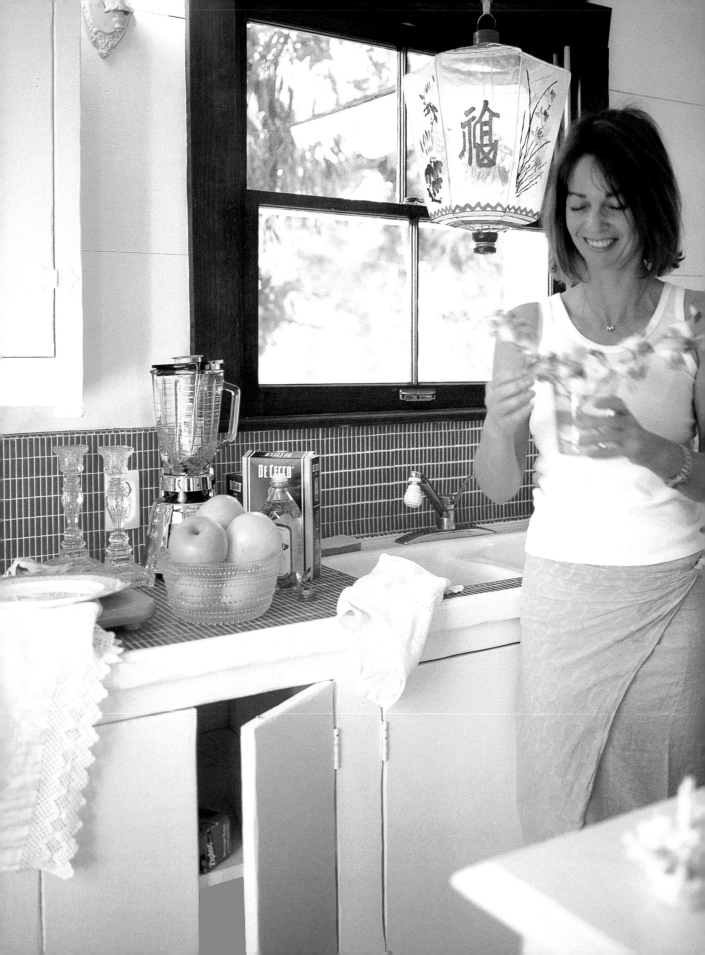

2

LEAVING IT
ALONE &
SURPRISING
MYSELF

W hen you have chosen and bought the house you want, it is important
to take a little time to look with an open mind at what is now yours
and make an effort to shed preconceived ideas. I surprised myself by
how pleased I became with some of the so-called compromises I had made—*after*
I'd had a little time to live with them.

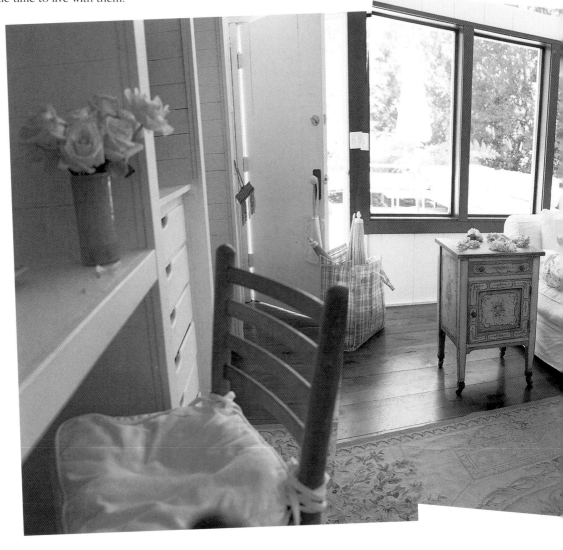

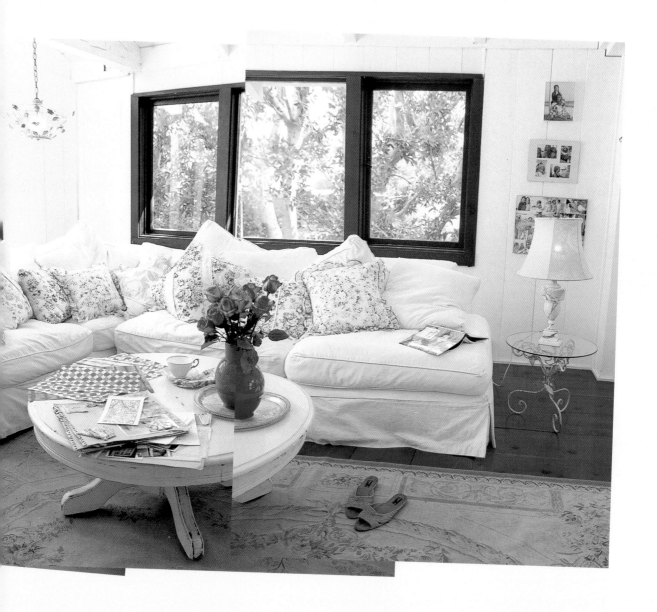

I didn't want white, white, white furniture in the living area of my guest house. I wanted more color, to be more eclectic here. A profusion of throw pillows helps to achieve that. The sofa and the little side table came from my last house (and my first book!). We removed the exterior of a wall-length cedar closet and kept the interior fittings for shelves. I left the trim of the windows dark here, to break up the white everywhere else. Again, there is no need for curtains. All the windows look out onto a private garden, and such lovely foliage.

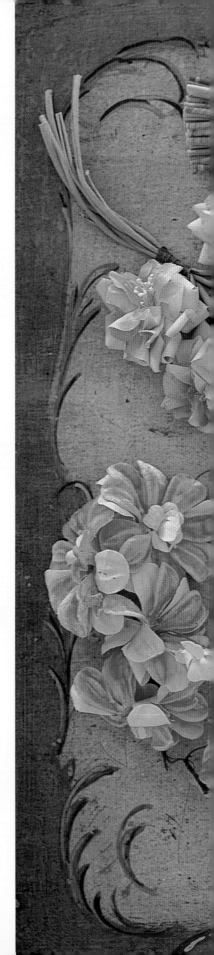

A flowerless room is a soulless room to my way of thinking; but even one solitary little vase of a living flower may redeem it.

—*Vita Sackville-West*

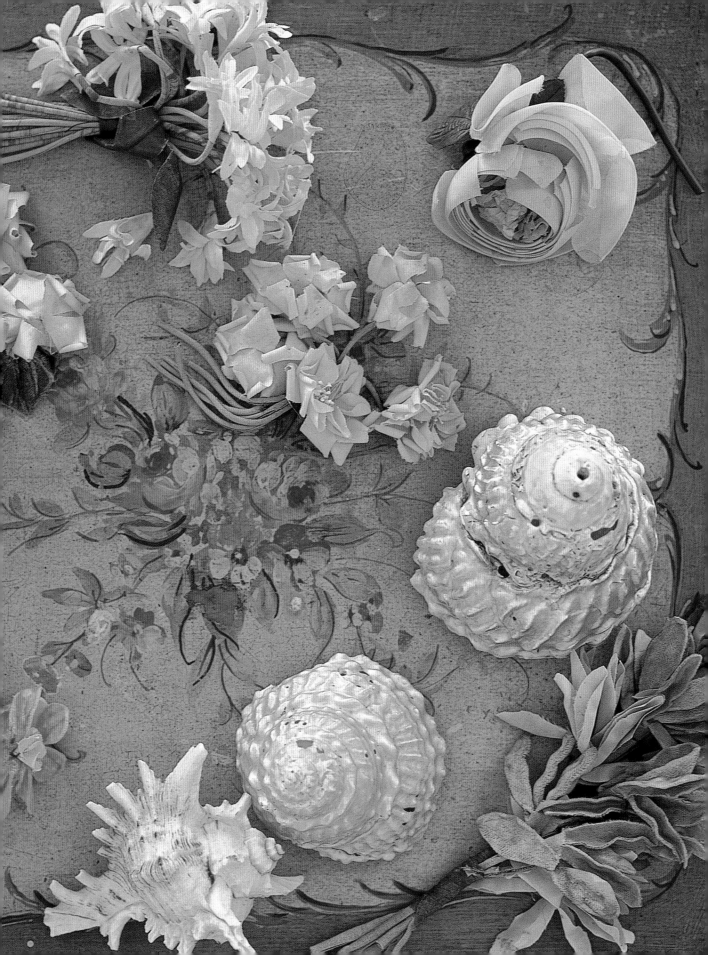

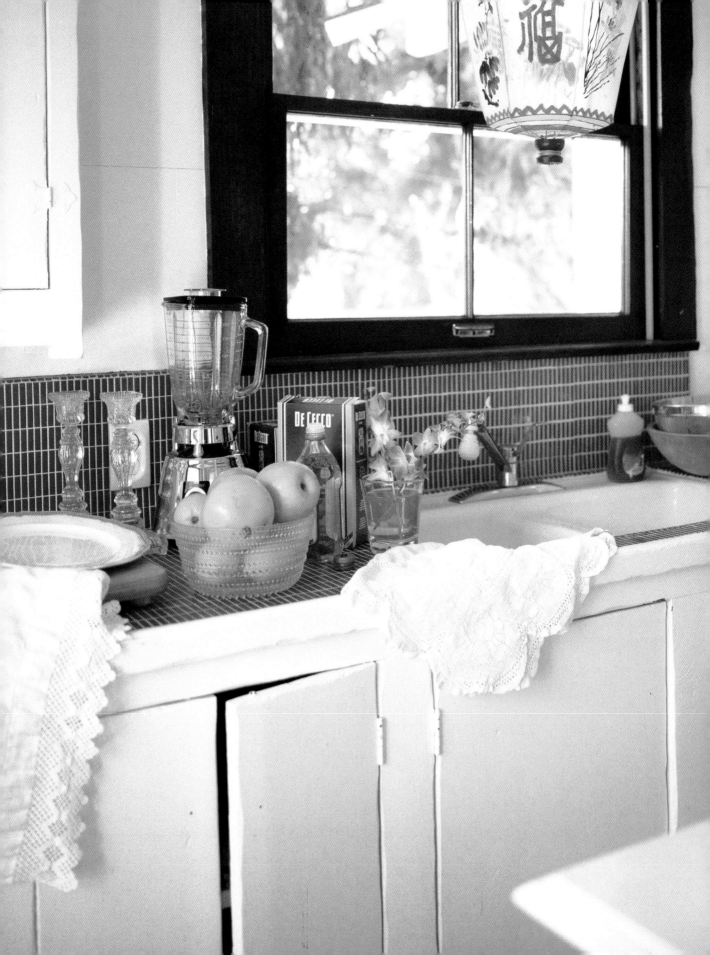

Once I made my list of essential changes, I had to review the house again, deciding how much of my wish list I could afford and choosing some of the compromises I would have to make. Perhaps the largest—but one that bothered me very little—was that I was not able to use some of the rooms as they had been originally intended: my bedroom was intended to be the living room; Jake's room, although certainly large enough to be a bedroom, had probably been the library (the walls are lined with shelves), and now it doubles as both Jake's bedroom and a throughway to Lily's room and the children's bathroom.

Opposite: In my guest-house kitchenette. The first time I saw this orange tile, I thought it would be the first thing to go. But after seeing it every now and again (remember, it's my guest house), I decided it might be fun to just leave alone.

Three of my choices to leave things alone involved the guest house, which is partly a coincidence. But partly, these compromises were made because it is easier to live with what isn't quite your taste when it happens to be in rooms you use the least. The decision was most certainly not because I thought "It's only the guest house."

The guest house is composed of a deck, two rooms, a kitchenette, and a bathroom. The front room had a huge walk-in closet made of cedar that ran the full length of the room. I didn't want to use up all that space, so I had the outer wall removed. Once that was gone, the economical solution seemed to be to leave most of the built-in interior. Rather than go to the expense of demolishing the fittings and refinishing the wall, I adapted what was left.

Now I have a small shelved cupboard for household cleaners and storage. Next to it are open shelves, which I pass several times a day, so I use them for inspiration and keep fabrics, lamps, mirrors, and parasols on them—and sometimes, hanging from a shelf, a colorful item of flea-market clothing. Beside these open shelves are some drawers. I don't really need them, but since the guest house doubles as my office (as well as Lily's music room, for practicing piano), I find a use for them. Along the greater part of the wall is a counter that we use for computers and other office equipment. The counter is too high, but rather than go to the expense of lowering it, I bought tall stools. And all these fittings—cupboards, shelves, drawers, and counter—are made of best-quality, pleasantly scented cedar.

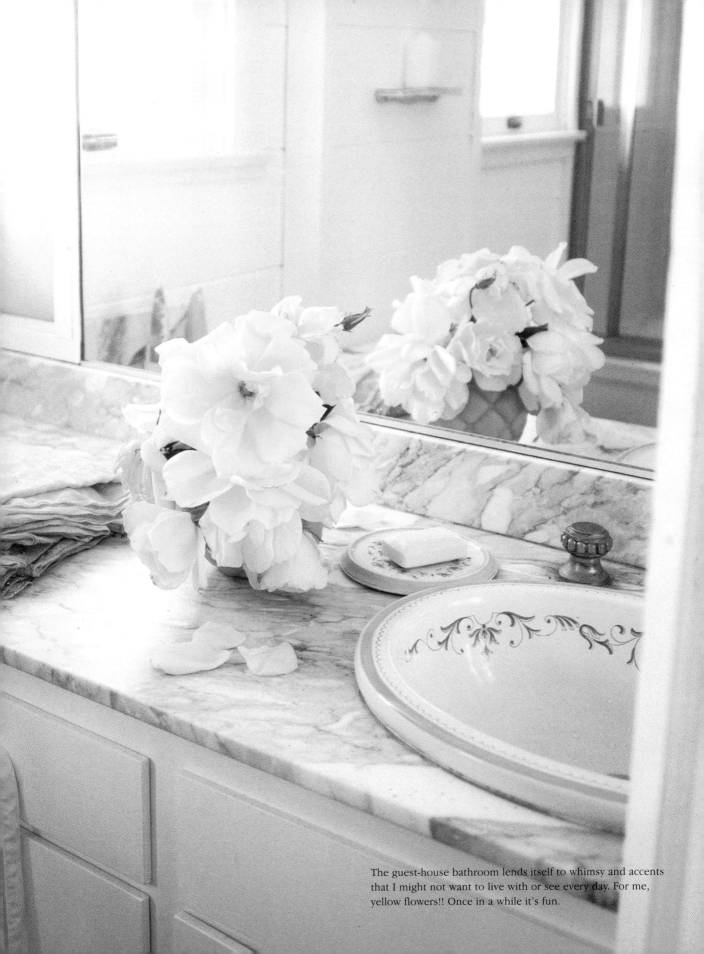

The guest-house bathroom lends itself to whimsy and accents that I might not want to live with or see every day. For me, yellow flowers!! Once in a while it's fun.

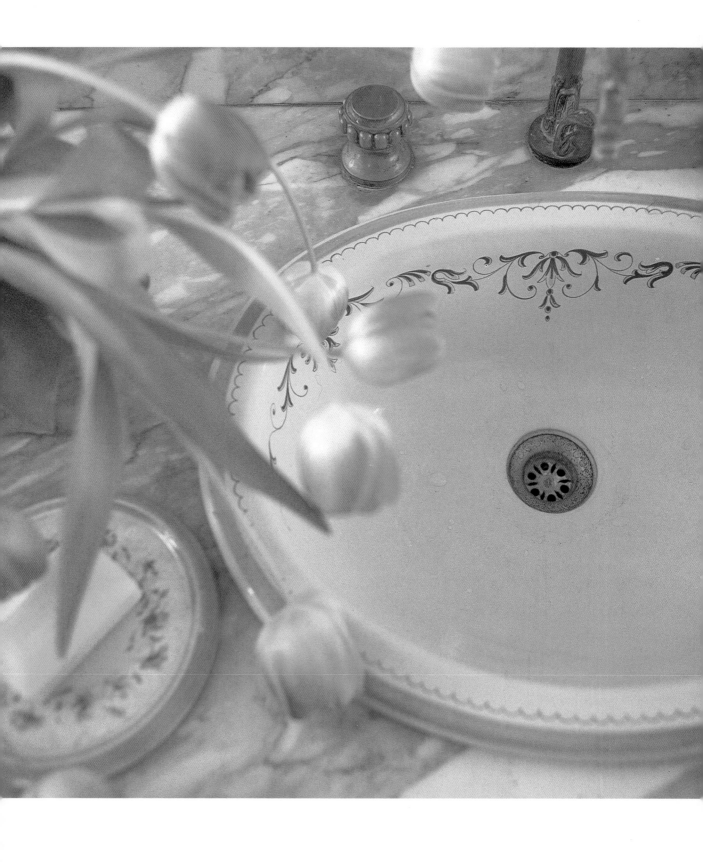

things kept

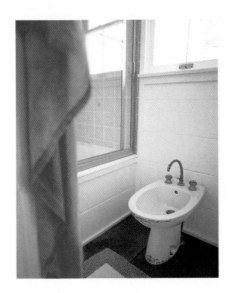

The inexpensive stained brown wood surrounding the windows in the guest bathroom was one of the rare areas to escape the white paintbrush. I felt like breaking up the white, and the brown border frames a lovely view of tall, closely planted trees.

The guest-house kitchenette countertop is made up of small, oblong orange tiles. When I bought the house, I imagined they would be among the first to go, but after a while I came to enjoy their cheerful energy. When it was time to redo the kitchenette, I left them as they were and painted the rest of the kitchen—except for the brown-framed window directly above them—my usual white.

The guest bathroom came with an eclectic range of materials: brass fittings, heavily veined gray marble countertops, a white porcelain basin decorated with a pink floral motif, blue-gray bath and shower tiles with intermittent pink detail. And a bidet. None of which I would have chosen, but with the woodwork and bathroom closets painted white, I have become fond of the way this room looks.

There are perhaps fifteen old-fashioned copper lantern-style electric sconces on the house and in the garden. I thought I would keep them for the time being but replace them later; now I have become quite attached to them.

Above: The bidet came with the house, and I kept it.

Opposite: A basin in the guest-house bathroom. I would never have chosen a pink-decorated sink or a marble with as much gray vein as this, but I was happy to leave it alone, and now I have become rather fond of the textures and detail. A nice variation on my white.

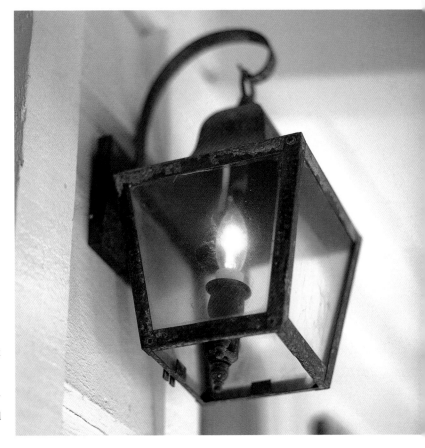

I can see now that having to wait a little—to relax into a new house, to live with objects or arrangements that might not be my first choice—is often a blessing. The restoration of a house deserves the investment of thought, consideration, and time, as well as work and money.

Fortunately, budgetary reasons prevented me from some alterations I was advised to make—most of them, it turned out, pertaining to convenience or saving time. But I like to spend a little time on my house—my *home*—and I enjoy strolling through the garden in the evening to switch on the outside lights, even though it would be quicker, and more efficient, to have had the switch moved to the living room. I also like walking through my garden during the day to answer the front door, although I could, for a price, have had an intercom installed.

I was urged to join the guest house to the main house, and I knew this would add to the resale value of the house. Although resale value should be a consideration when making such a decision, it should not be a priority, and my decision not to join the two houses was largely budgetary as well. As a result, the main house has become the more peaceful house; we eat, sleep, and talk there. The guest house tends to be where activity takes place—it houses the computers, the baby-grand piano, and the only television. It is where I work and where Lily practices the piano.

Above: There are about fifteen of these lanterns dotted about outside. Another example of something that, were I starting from scratch, I might not have bought, but innocuous enough to let be.

That the television is in the guest house ensures that I am not seduced into watching more television than I think healthy. It also tends to make viewing somewhat of an occasion—such as when the whole family and our friends assemble to watch the Oscars. Sometimes, when it rains, I wish I had joined the two houses; but more often I enjoy the time spent between them, feeling the sun on my skin, seeing and smelling flowers and plants on the way. Then—and that is most of the time—I am glad I left well enough alone.

Things to consider when leaving it alone:

- Live with what you've bought for a little while. Relax into it.

- Don't change your mind more than you have to.

- Choose what you are willing to compromise on.

Above: Flea-market table with glass top. An alabaster lamp base with a Shabby Chic linen shade.

Opposite: I lucked out with the existing glass doorknobs in the guest bathroom. They're sweet.

EVERY EXIT IS AN
ENTRY SOMEWHERE ELSE.

—*Tom Stoppard*

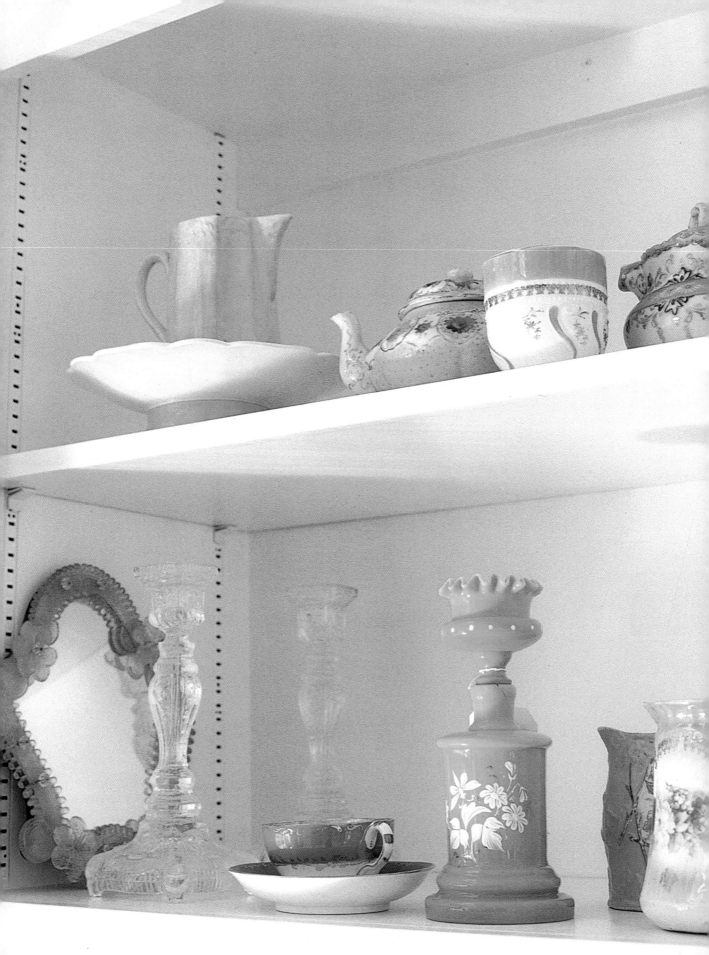

3

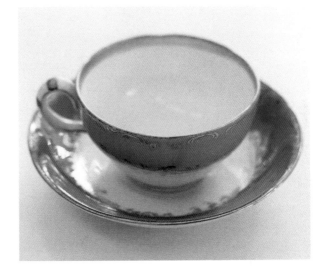

HALLWAYS, NOOKS & CRANNIES

The Garden

My daughter, Lily, says, "I like walking through the tunnel and see-
ing the flowers—it's like a secret garden."

The tunnel under the guest house is now bright and invit-
ing. I walk out of its cool shadows and find myself in the magic garden. There
are small, wonderful places in the garden—and in the house; they are the
perfect places to play hide-and-seek. Some of them are closed and secret,
nooks and crannies, special places in which my children—or I—like to rest
for moments of quiet and privacy. Other areas, such as the hallways, are spe-
cial because they are open—the transition between rooms—and often have
the best natural light in the house.

As one enters the garden from the street, on the right is the spa. In the
days when the garden was a dark and eerie place, the spa was a spooky little
cave under the dark brown deck of the guest house. It hadn't been used for
some time, and everything imaginable was growing out of it. Now the spa has
been relined and retiled in the same colors as the pool, and is surrounded by
piles of pale towels, sarongs, and hurricane candles—a very friendly little
place to relax and unwind.

Opposite: In my spa area colorful sarongs, plenty of towels, and hurricane lights
create a little bit of heaven in my backyard.

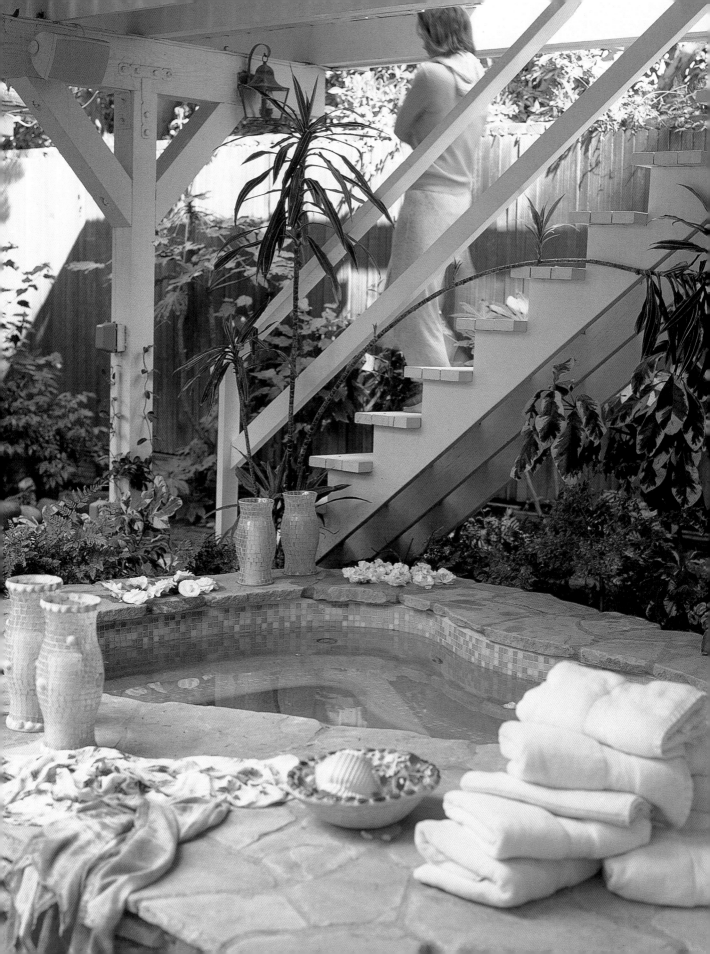

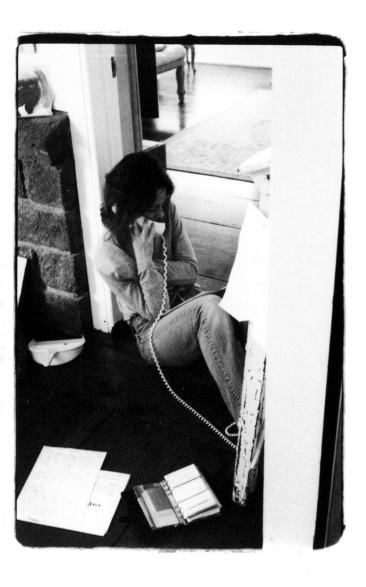

I enjoy the spa, but I would never have gone to the expense of installing one; a cedar-lined sauna wouldn't have been on my list either. So I was fortunate to find both luxuries already included. Although I have hung colorful pareos in the sauna, I rarely use it, and Lily has made it her special nook.

There are two hallways of which I am particularly fond: one in the main house between the living room, the kitchen, and my bedroom, and the other in the guest house. In my hallways, the light often comes from several directions, and so they are shadowy and beautiful, particularly in the hall off the kitchen, which I'm constantly walking through. When we moved into this house, the telephone was in this six-foot-long passage, between the kitchen and my bedroom; I left it there, and now spend more time here than I would wish, sitting on one of the little steps that didn't get smoothed out, with a notepad on my knee. But because the space is so pretty, I don't mind lingering.

Above: The telephone reaches everywhere; sadly, necessity comes with the territory of owning a business.

Opposite: Cedar-lined and cedar-scented, the sauna doubles as Lily's playhouse.

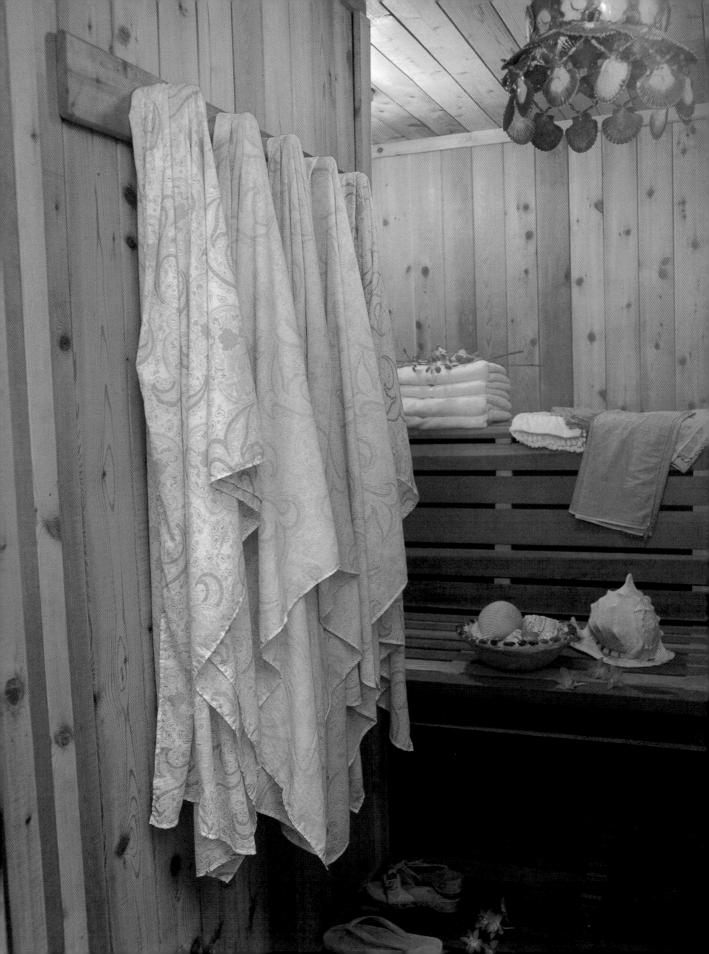

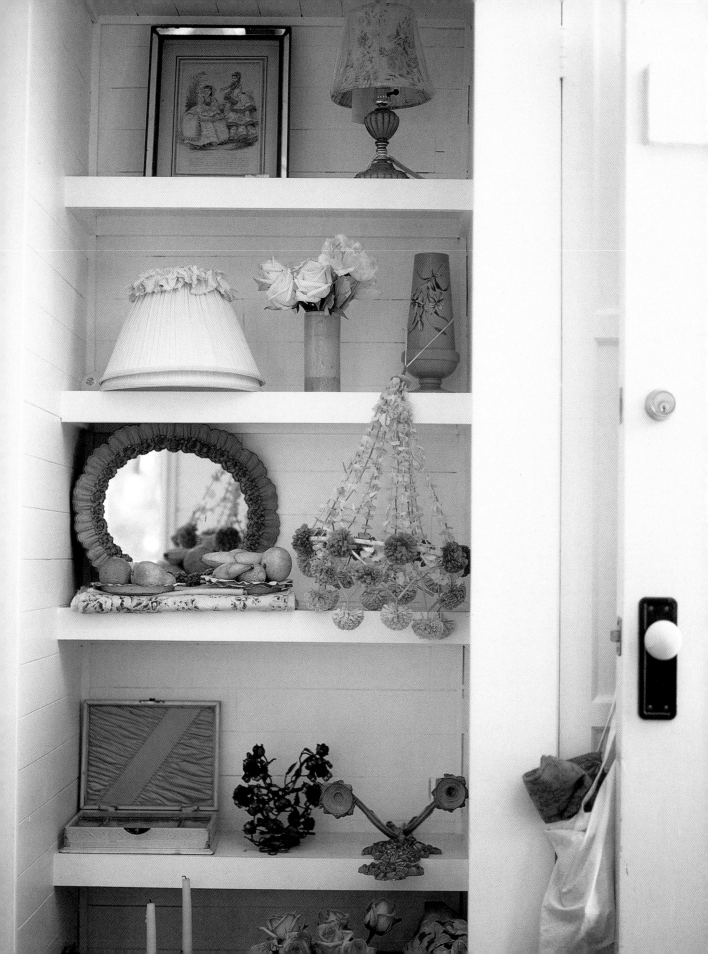

Opposite: These things are usually somehow tied into a new product or design I am working on for Shabby Chic. Sometimes an item may sit here for quite some time, until one day I see it in a certain way, and it becomes my inspiration.

a perfect nook

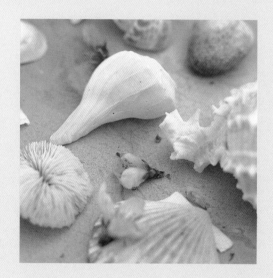

Opposite: A perfect spot to hold all the things needed at various times for my nearby dining table. Again, a lovely place to glance. Nothing is ever here long.

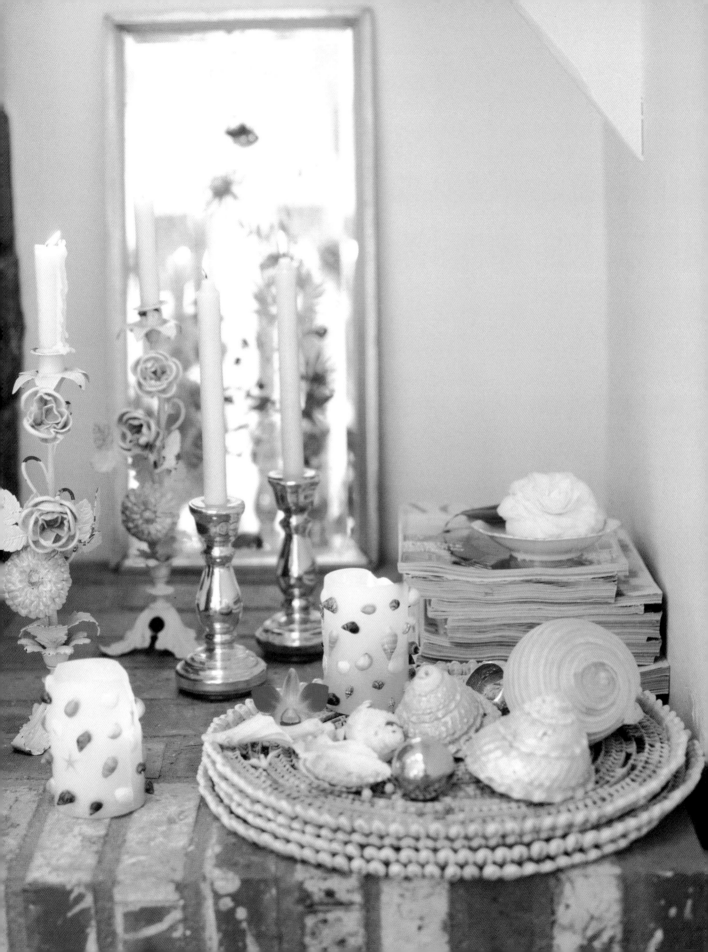

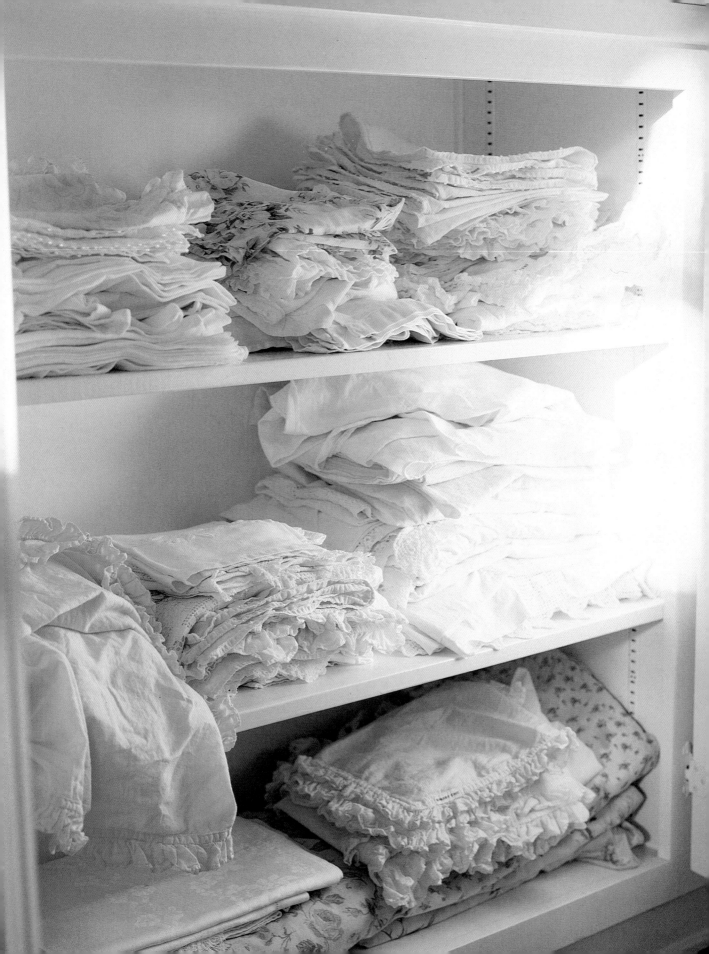

Some of the cupboards in the kitchen are high, and Lupe (my housekeeper and much, *much* more) isn't very tall. When I realized we would need a ladder and didn't have anywhere to store it in the kitchen, I found a pretty green one and gave it a place beside the telephone, across from my parakeet Tweety's freestanding cage and my nonoffice desk in the hallway.

The guest house hallway is a little longer, about eight feet long. It joins the guest bedroom/music room to the bathroom and also to a secondary staircase. It is the perfect place for a quiet watercolor painting, a laundry hamper, and one of my inspirational notice boards—covered with pieces of fabric, drawings, scraps of paper. I try to arrange my house so that there are as many places as possible to inspire me. My hallways are among these places.

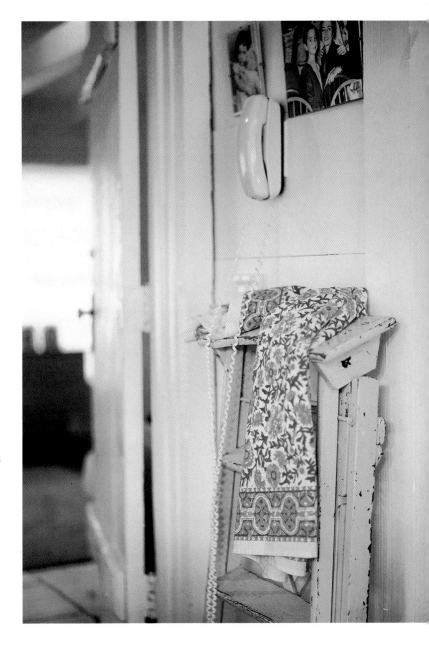

Above: Hallways and thoroughfares are part of the house too, not to be left out of the overall decor. I spend hours talking on the telephone on the floor in this hallway. The green ladder and the birdcage cover serve two necessary functions but also add a lovely touch of color.

Opposite: Every cupboard should hold things of beauty or function. I allow for one junk drawer or cupboard in my house. Otherwise, whenever I open a cupboard it should be like Christmas, beautiful and sumptuous. It doesn't need to be organized perfectly.

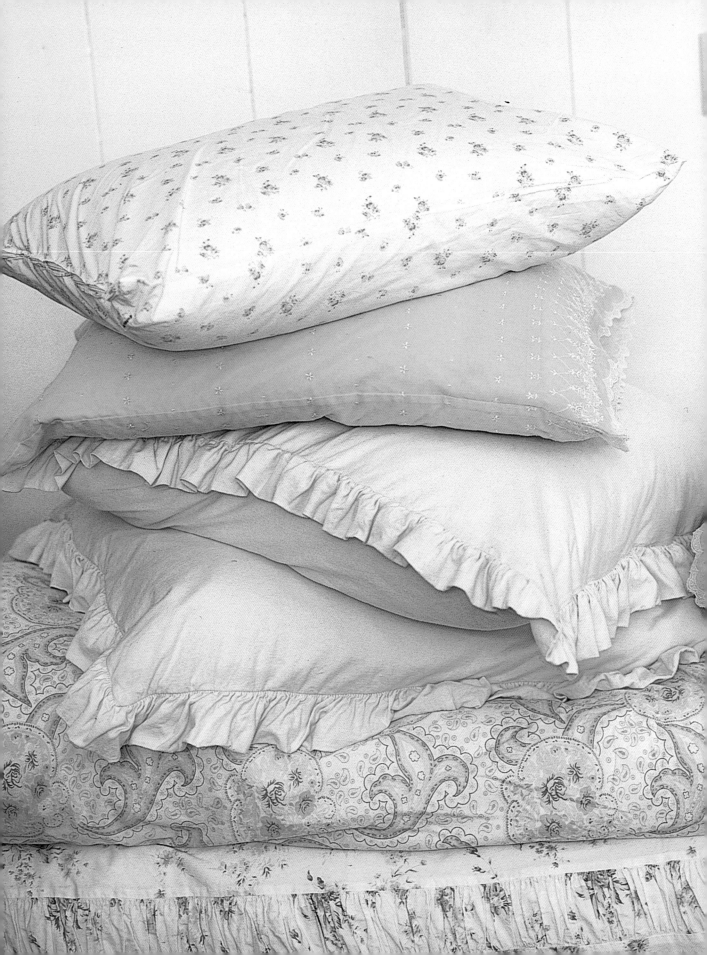

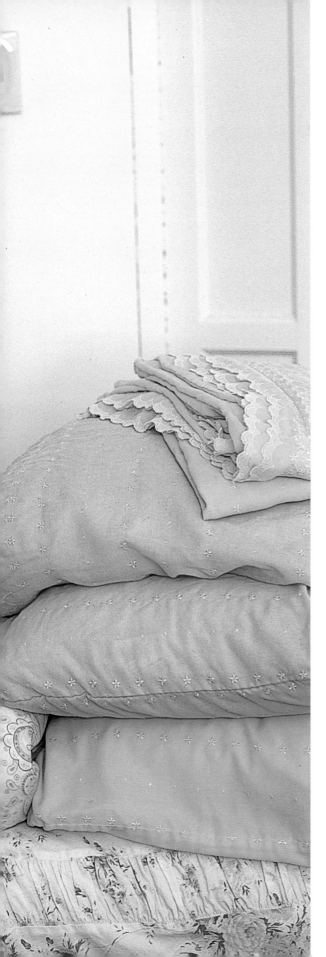

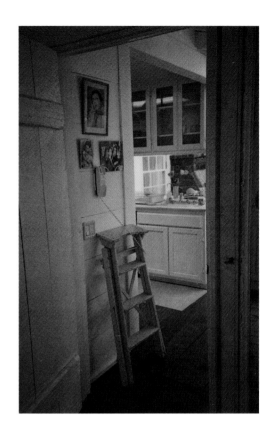

It is a mistake to ignore hallways, or to treat them as meaningless dead space between rooms. The sum total of hallway space may be greater than the largest single room in any house; you may, as I do, spend as much time in hallways as in the rooms proper. So keep your eyes open for small, useful pieces of furniture that can make good use of this space: a narrow bookshelf, a small end table, a lonely single chair. Little pieces can have an intimate charm that more imposing pieces could never match, and can also be quite inexpensive and easy to get home and move around.

Left: Some things are so pretty that even when not in use, I don't want to pack them away in a cupboard. I like to see this overflowing stack of duvets and pillows.

119

Even better than simply adding unnecessary furniture is finding beautiful examples of completely useful items that you don't want to hide: My pale blue laundry hamper couldn't be a better color, and I'm glad the bathroom can't accommodate it; it would be a shame to hide the lovely green stepladder in a utility closet, which I don't have. Both items serve important purposes, and serve those purposes all the better because they're attractive.

There are several nooks and crannies in the living room. Since the living room is not large and also serves as the dining room, useful and attractive storage space is important. Between the fireplace and the door to Jake's room is an alcove with room for a small table, where I store china close to the dining table. I use everything pretty I own; I don't see the point of having cupboards full of "special" things gathering dust. If I don't use something, it goes out. I either give it to a friend, or Lupe finds it a new home where it will be appreciated—and used. This way my cupboards and closets are not overfilled. When I open them, I look at their contents with pleasure, not despair or guilt.

Opposite: Hallways often catch the best light and shadows in a house. Here is a perfect example of a simply beautiful spot. A path well trodden is often as important as the destination. Painted wicker laundry basket: the color and condition were perfect as I found this, but I did line the inside with muslin.

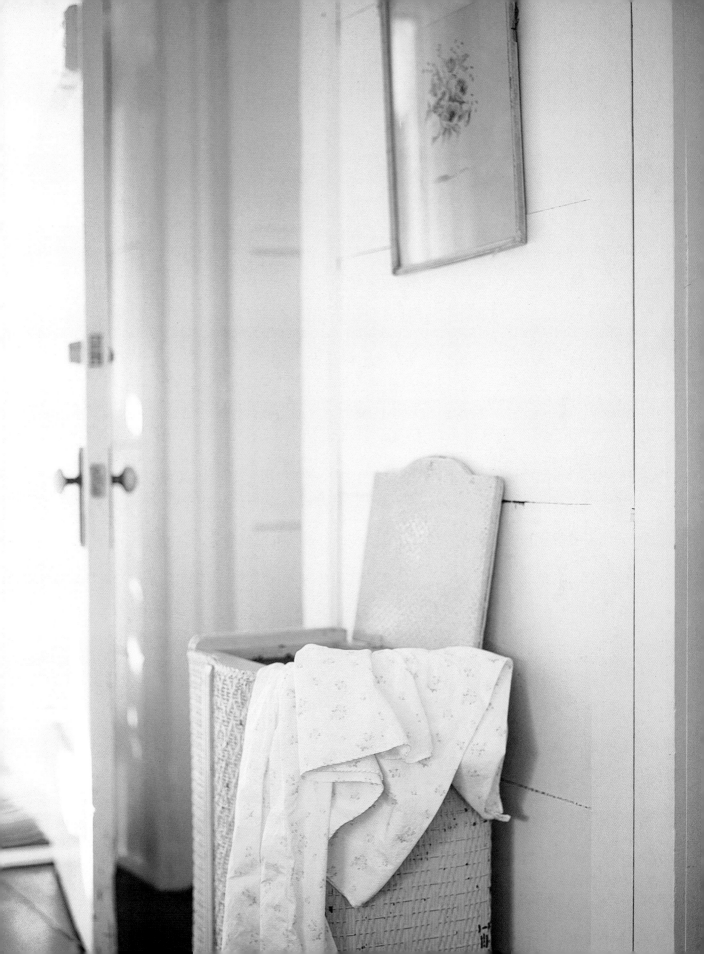

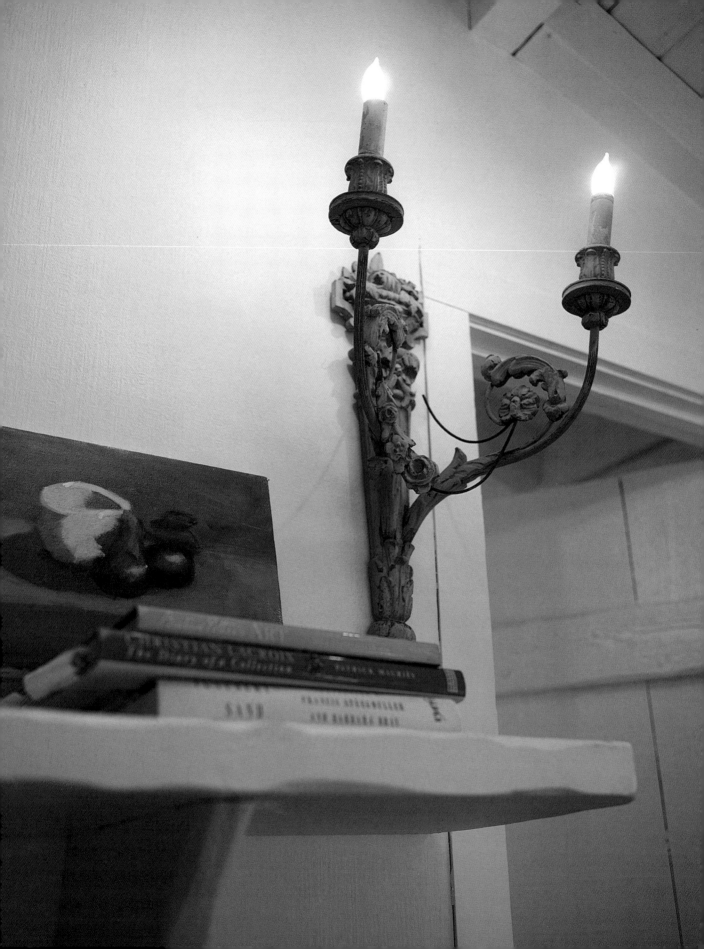

I have at last found a resting place for a sconce I brought with me from my last house (as seen in my first book): a shelf on the wall just beside Jake's room. It lights Jake's painting of two plums and a bowl. I propped a couple of favorite flea-market floral paintings beside it, and in its own way, this shelf became a small nook.

Above: Every nook and hallway deserves good lighting. I'm always on the lookout for great old sconces. But I only use them if there is preexisting wiring; it's way too much work to wire a sconce into a finished wall.

Opposite: Proportionately wrong, perhaps, to have a light fixture of this size here, but next to my son's painting seemed to me the perfect place for this pale green wooden sconce.

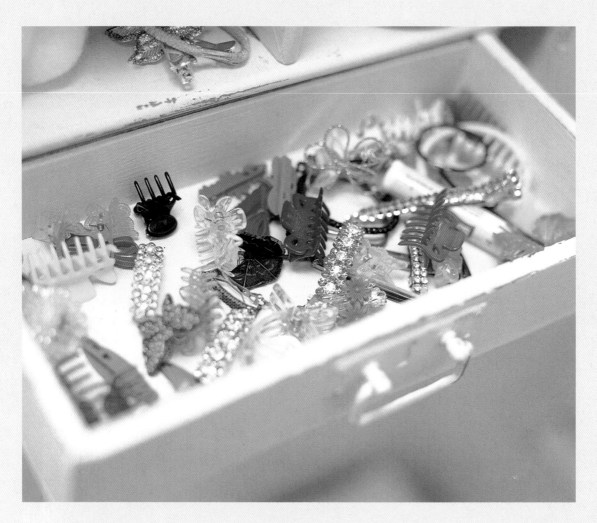

The smallest cranny is in the children's bathroom. Hung on the wall is a lovely flea-market cabinet, the door of which is inlaid with an old looking glass. It has well-proportioned shelves and little drawers for Lily's hair ornaments, like a treasure box in a secret garden.

Above: A teenage girl's drawer. Fun.

Opposite: A bathroom cupboard: old, refurbished, painted white, distressed, now elegant with its oval looking glass, and luxurious with the pampering cosmetics and toiletries inside. They are all, in an uncontrived way, pretty colors and pleasing shapes.

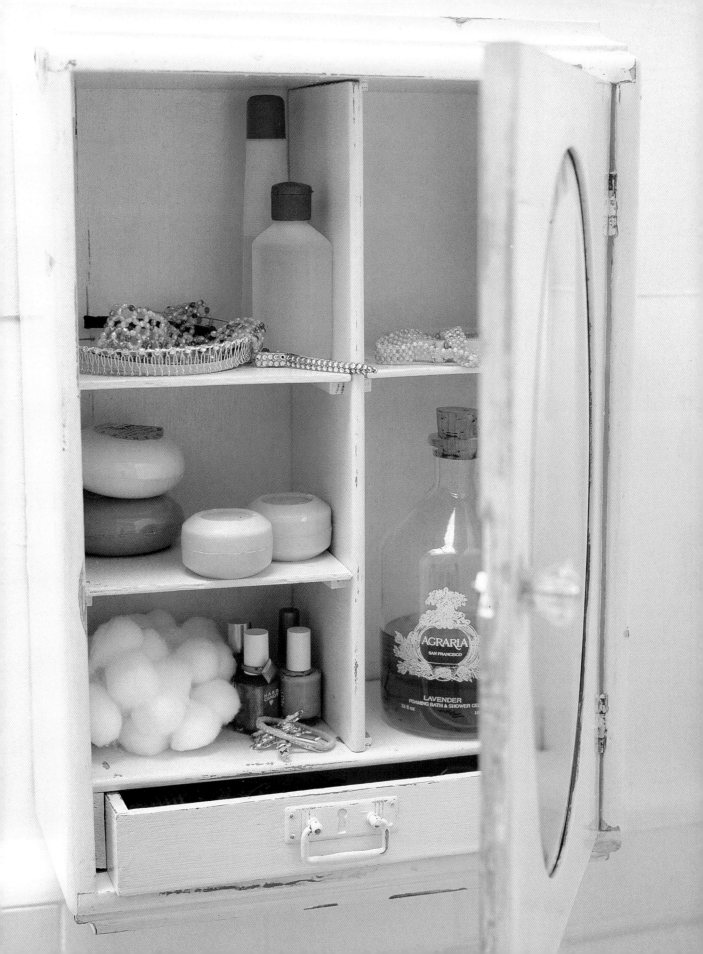

Though we travel the world over to find the beautiful, we must carry it with us or we find it not.

—RALPH WALDO EMERSON

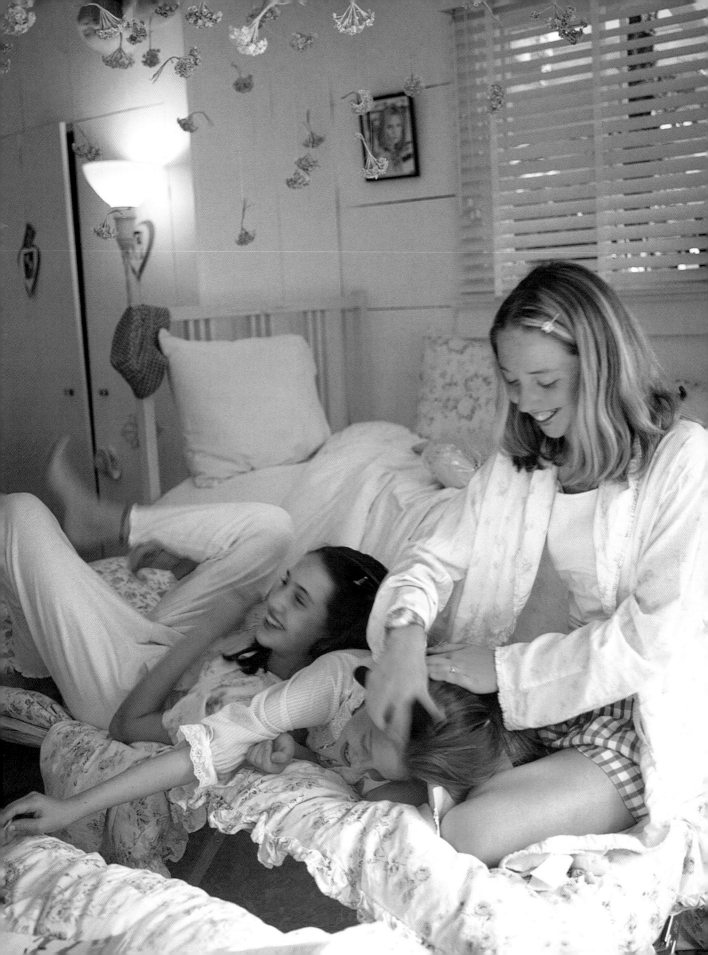

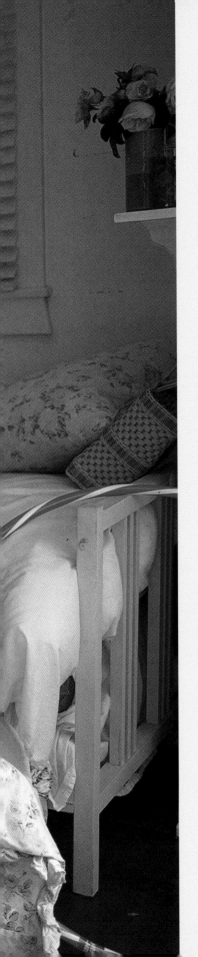

4

SLEEPING &
SNOOZING

My house is a hive of activity during most of the day: The children and their friends are in and out; Lupe keeps the house clean and battles the waves of laundry that each day brings; I often work at home: and now that I have a television show to fit into my already tight schedule, the energy level in the house is often high.

And so, of course, is the stress level. I cope with this by having a series of little havens around the house and garden, places where I can rest, think, read, do quiet work, and even nap occasionally.

If I need ten minutes during the day to restore my energy, I lie on my hammock.

The hammock is lined with a feather bed and pillows, both covered in one of my pale floral patterns, and is slung between two sturdy eucalyptus trees. Every year I have these eucalyptus laced (thinned out) to allow the sun and sky into my garden. Their heavy leaves, the bane of the lawn and pool, provide shade as I lie looking at the garden, at times thinking that this is what heaven must be like. The gentle rhythm of the hammock, the hum of the garden, and the scent of the flowers all revive my spirits, and soon I am ready to rejoin the world.

Above: A deviation from my pinks: the cool teal colors in some of my new bedding designs.

Opposite: The most inviting snoozing place for me; I feel grounded by the rhythm of the hammock, lined with a feather bed and large down throw pillows, and the solid size of the huge eucalyptus trees. The environment makes for a perfect nap. Next to the hammock I have a contemporary teak dining table and chairs. I wanted something I didn't have to worry about; it didn't seem like the spot for Shabby Chic worn metal or painted wicker.

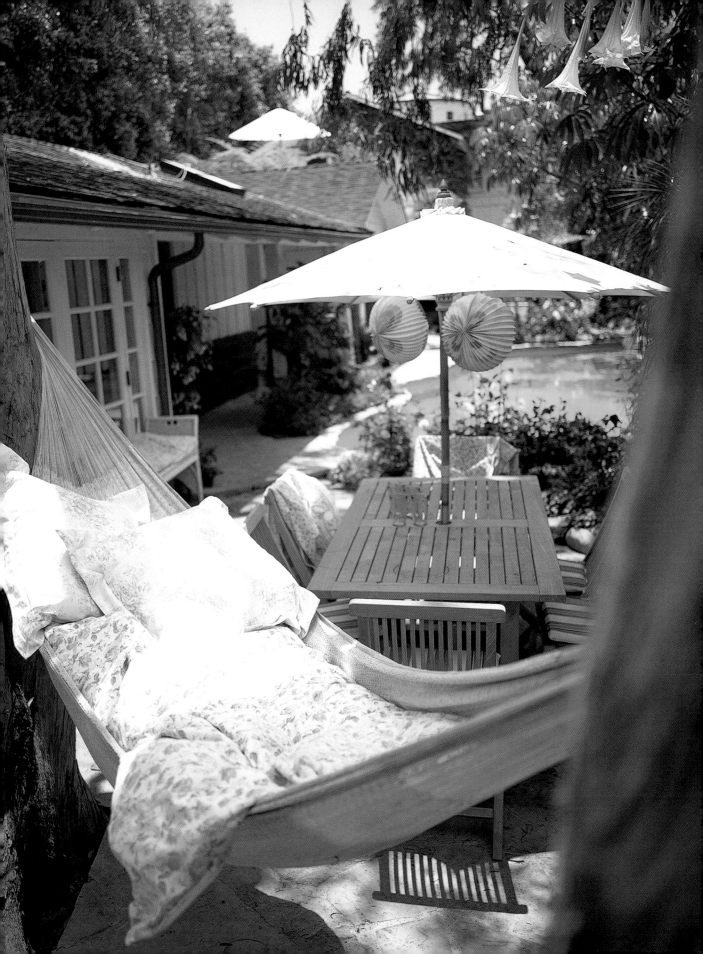

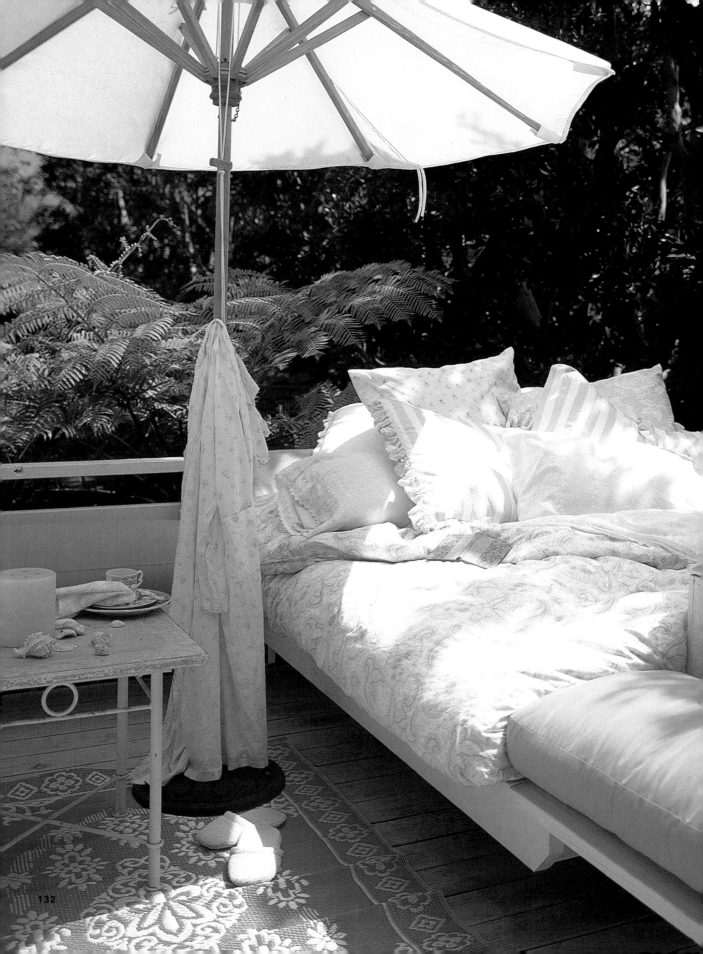

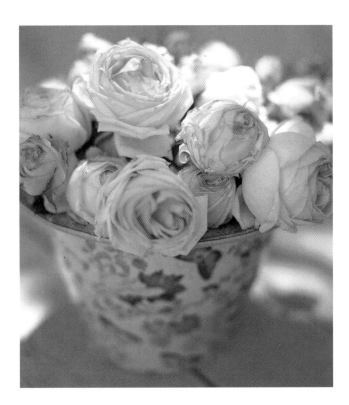

The guest house has a large and sunny deck. When I bought the house, the whole deck was lined with bench seating. I expanded part of this banquette with planks to make a platform for a large mattress and cushions, which are covered with a dusty pink waterproof fabric so they can stay outside, and there is also a large patio umbrella nearby. I often spend an afternoon here, thinking and doing quiet work. Sometimes I have a summer nap under some light bedding; if this pleasant time stretches into the evening hours, I add a mosquito net, which serves its true purpose.

Above: Pink tissue-paper flowers, bunched in an unusual blue-and-white plant pot. I found the pot in England.

Opposite: My sun deck. The cushions are covered in a waterproof dusty pink cloth, which acts as a good base, and I can leave them outside in all weather.

133

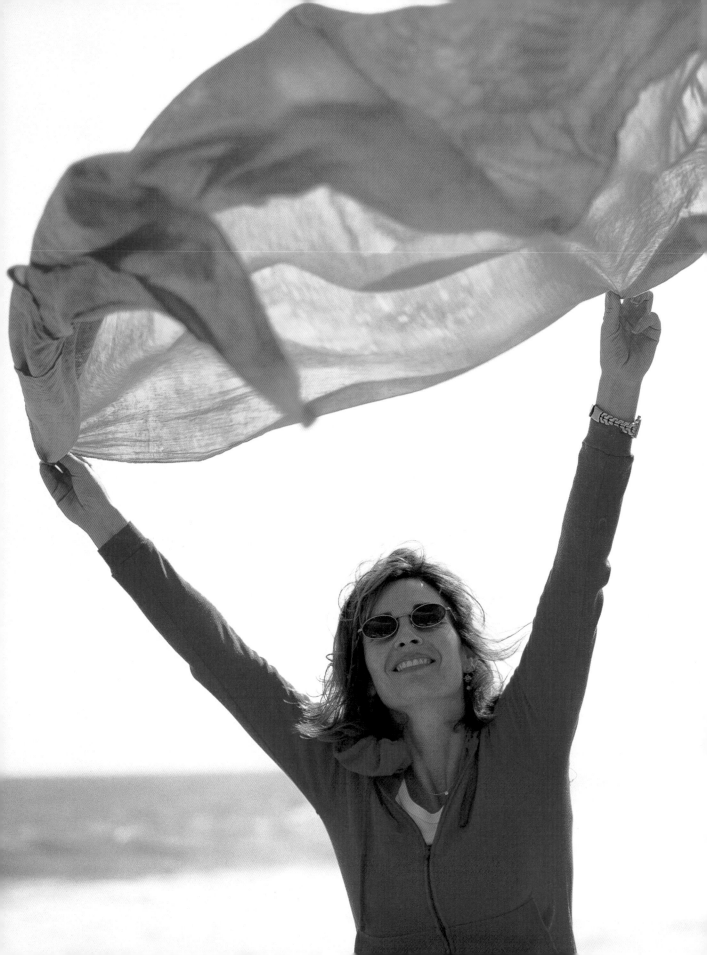

The future belongs to those who believe in the beauty of their dreams.

—ELEANOR ROOSEVELT

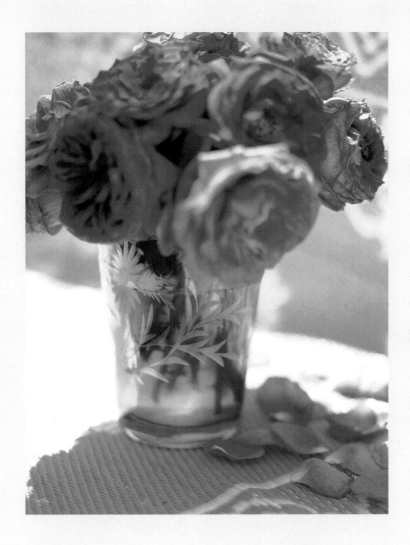

Above: A raspberry etched-glass vase, with the perfect mouth for a generous display of berry-red roses.

Opposite: Creating a place to rest. There is something so freeing about the elements of the ocean.

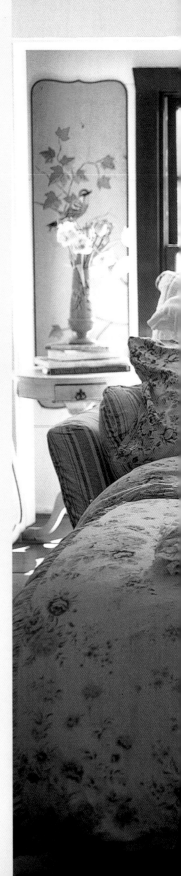

Although the bed in the guest room is a convertible sofa, it is very luxurious. There is no need to compromise on comfort with a sofa bed—it should be just as plush as though one slept on it every night. My guests are here because they are people I care about, and I wouldn't dream of using castoffs or second-rate furniture in my guest quarters. I like my guests to have plenty of soft, *soft* pillows (the arms of the sofa are a bonus, since there are big pillows to stack against them) and pretty sheets.

In the guest bathroom I have lots and lots of fluffy towels and deliciously scented soap, freshly unwrapped before guests arrive. And, of course, flowers are everywhere—picked from the garden, given by friends, or bought.

Above: When I dye fabrics at home, there is always an element of surprise in the end result, but my palette is forgiving to different shades of pinks, greens, and blues.

Opposite: A sofa bed doesn't have to be lumpy and uncomfortable. It can and *should* be just as luxurious as any other bed. Here I have extra pillows, all with a pink theme and an accent of turquoise.

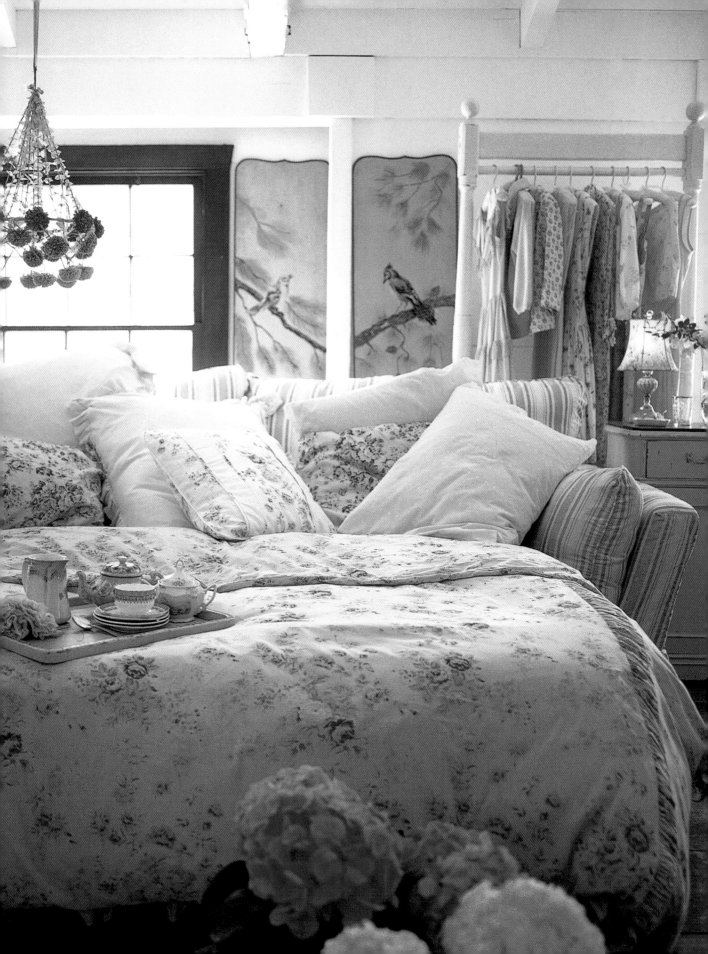

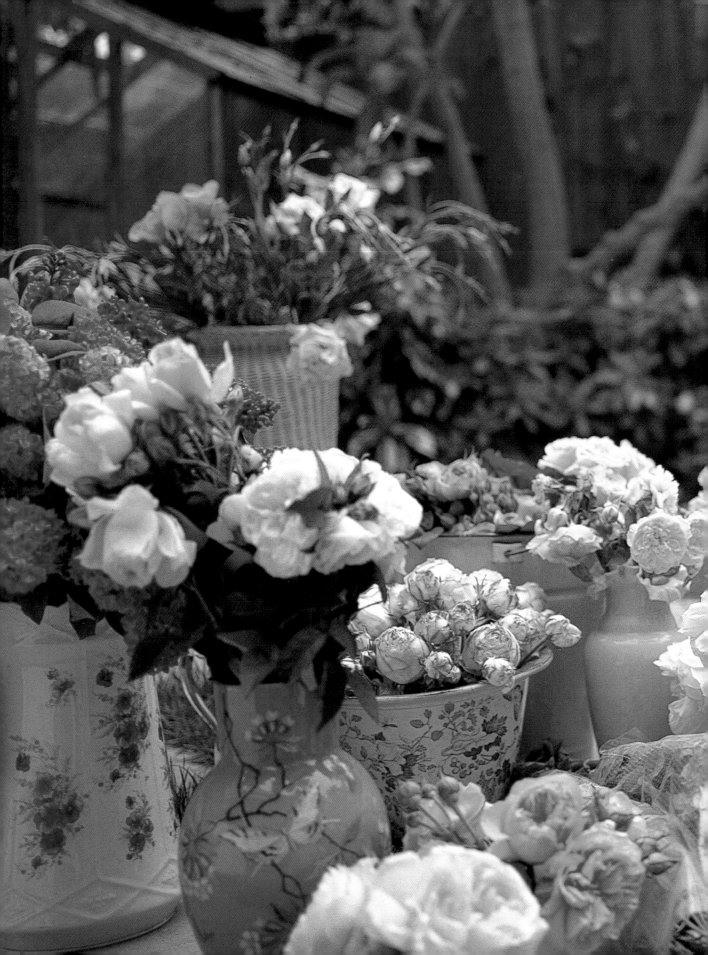

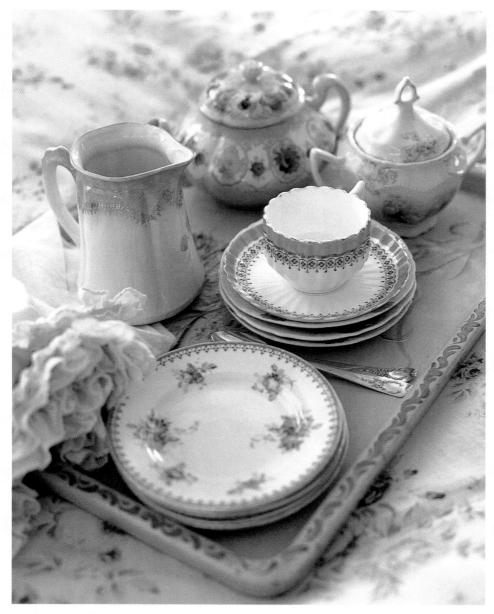

There is no closet in the guest house—remember, I tore out the walk-in closet—but there is an attractive and functional wardrobe rack. On it, at all times, hang some of my prettiest vintage dresses—inspiration for a clothing line I will design one day—but there is also plenty of room for my guests' clothing. And I've also chosen a variety of vintage hangers, some fine and covered with faded green velvet, some padded and covered with floral fabric.

I keep the kitchen and refrigerator in the guest house well stocked, with a good selection of teas and a big bowl of fresh fruit. But even so, I like to bring my guests a breakfast tray with some of my prettiest china.

Above: Typical tray with mismatched china. Pink floral theme.

Opposite: A bedside treat for a guest.

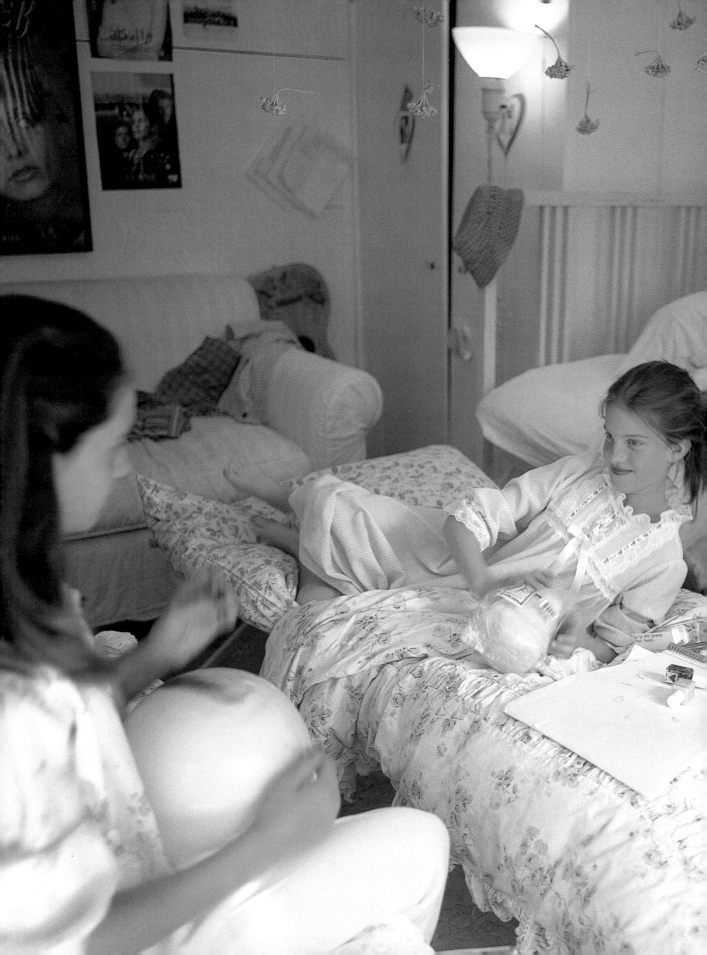

slumber parties

My children are at an age when much of their social life involves sleepovers and, for more special occasions, slumber parties. I love to have my children's social life in the home, and I find slumber parties easy and fun: It is effortless to make them festive and exciting (and it is a comfortable and unobtrusive way for me to get to know their friends). The children provide their own entertainment, and I provide food, refreshments, and plenty of inviting bedding. There is always an abundance of pillows, linens, and comfortable quilts around the house, luxurious without being in any way extravagant. Everything is simple, but it is sumptuous—feather beds and duvets are stacked up in open view on an army-cot spare bed—and it is all durable, washable. The kids and their friends sleep on the sofa bed or sometimes just curl up on a mushy couch with lots of soft, luxurious bedding.

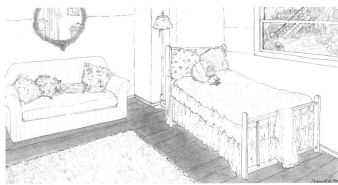

Left: A slumber party for my daughter and her friends. Paper forget-me-nots hanging from fishing line give a dreamy effect. A basic army cot is dressed with a luxurious feather bed; sumptuous duvets maintain my standards of comfort and beauty.

143

dreamy

Above left: A fuzzy feathery pink telephone for teenage phone calls.

Opposite: A vintage night jacket—charming.

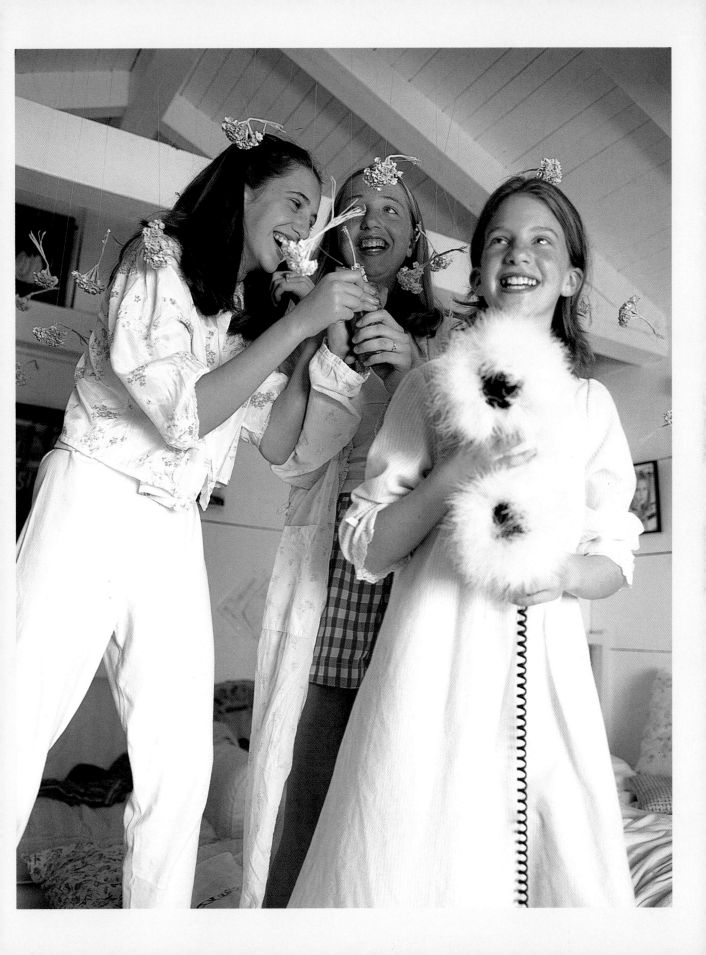

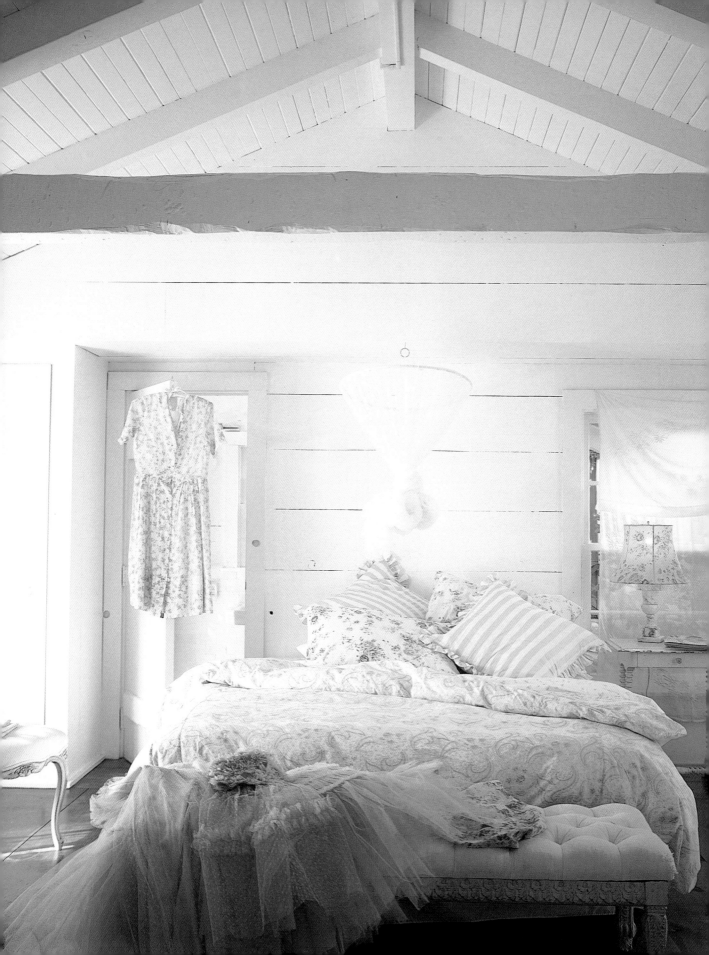

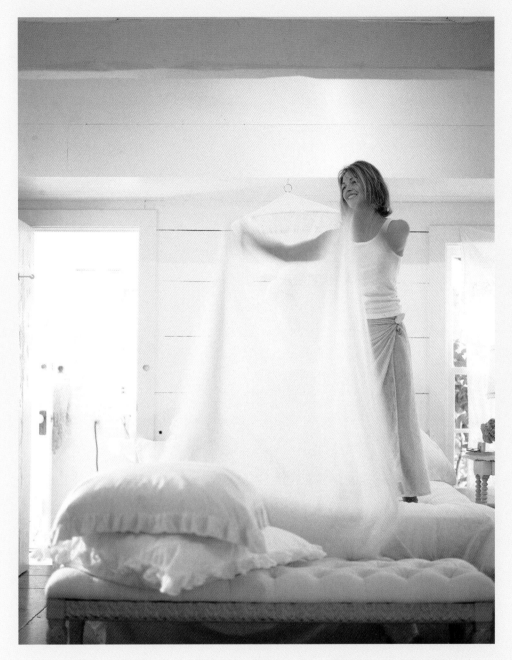

It is this same abundance of bedding—especially pillows—that enables me to skip the fussiness of a headboard in my own pared-down bedroom and that provides great flexibility with the children's rooms: No matter what their current decorating fascinations, their rooms always share the same comfortable look with the rest of the house.

Opposite: My palace, my dream. Caribbean . . . French . . . rustic . . . and casual sexy elegance.

We are fortunate to live close to the beach—another superb spot to take a nap—and I make sure there is also an abundance of portable, lightweight beach stuff—sarongs, towels, mats. Sometimes at night I can hear the ocean from my bed, and it reminds me that the beach is a peaceful place for quiet times.

Above: I enjoy making a comfortable place to nap on the beach.

Opposite: Nothing is more angelic than a resting child.

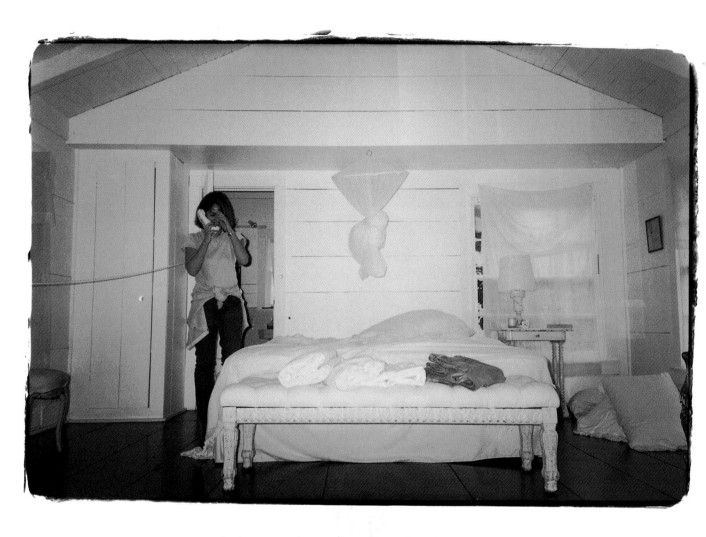

But on a rainy night there is no place more inviting to sleep than my own bed. Piles and piles of pillows, eclectic bedding, and a mosquito net suggest an incipient canopy overhead. My bed is neatly but not formally made, so it invites me to plop onto it if I have a few minutes to spare. Maybe to read, meditate, or do nothing.

My bedroom and bathroom are where I like to enjoy scents from my aromatherapy diffuser. I put a few drops of relaxing lavender—or if I feel the need for calming energy, some eucalyptus—into the dispenser and breathe them in. My sense of touch is satisfied by the comfort I draw from the texture and softness of my bed and furnishings; my sight is fed by the beauty around me. Since the sense of smell is more powerful than the sense of sight, it often draws me back into the past. It would make me happy to think that my children will one day be drawn back into memories of me and our house when they breathe in the scent of lavender.

s o f t n e s s

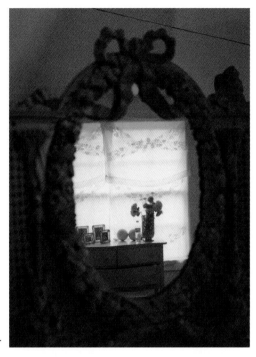

A beautiful reflection, beautifully framed.

A pile of blue jeans is always a welcome
sight at the foot of my bed. I never know
when I may need them, and Levi's blue is a
favorite color.

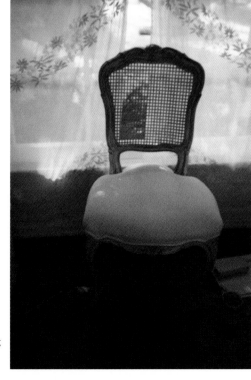

I think a black-and-white photograph
shows an uncontrived beauty. Nothing
hiding behind color.

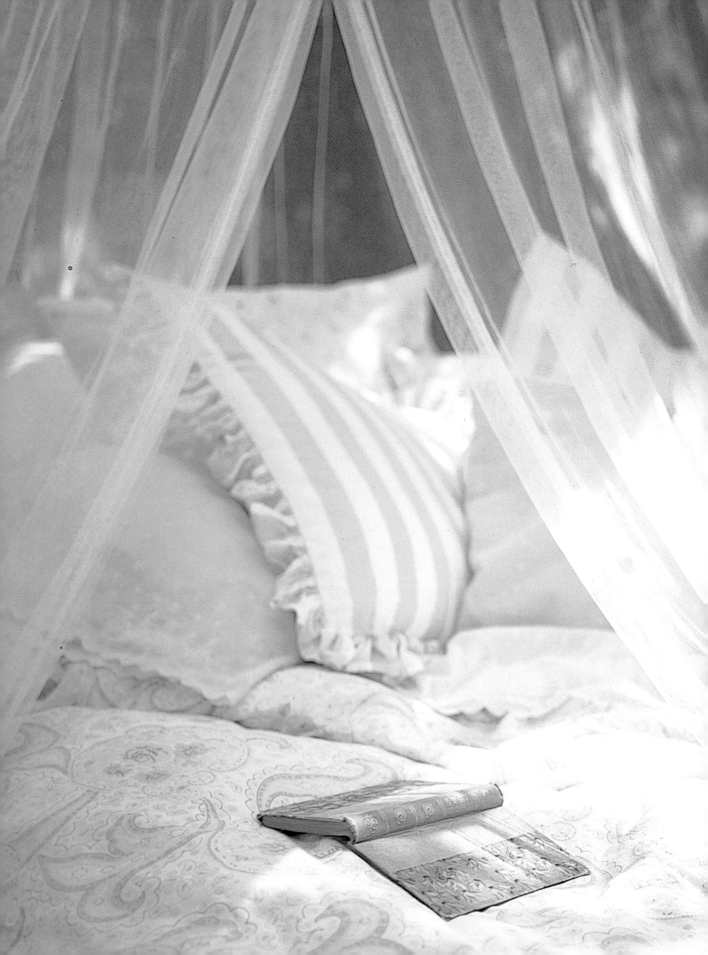

Nothing happens unless first we dream.

—Carl Sandburg

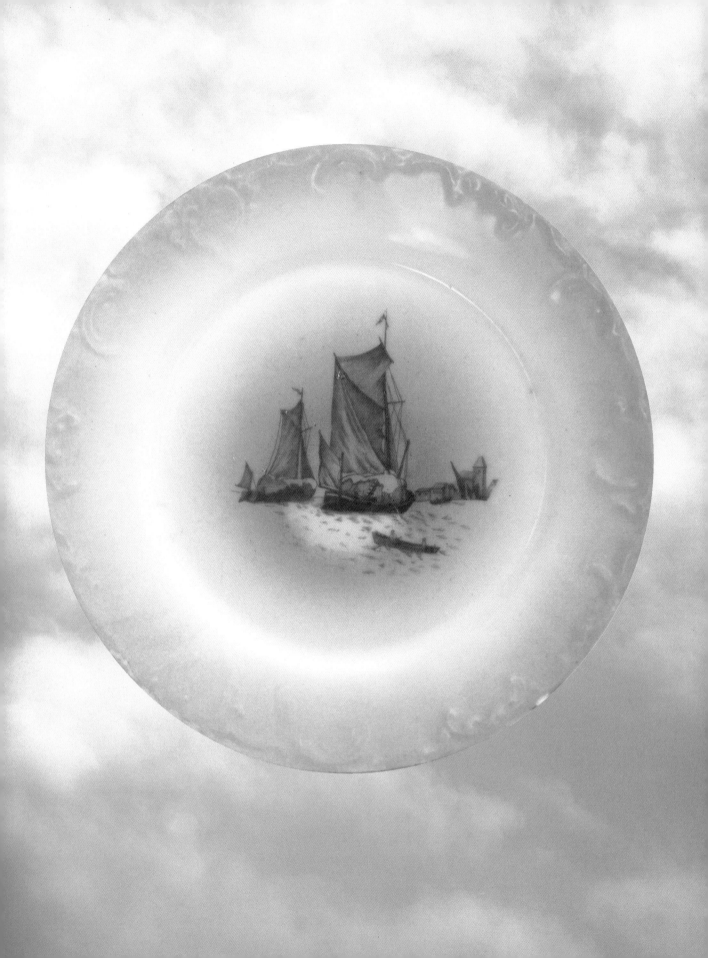

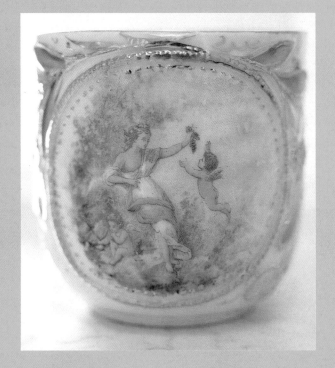

5

CUPIDS, CHINA
& GIRLS
IN PRETTY
DRESSES

I love to entertain—to be with my family and friends, to use all my pretty china, to dress up a little. I keep entertaining painless and anxiety-free by a mixture of modesty and abundance. In my house there is no "best" china, nothing that I put away for special occasions. When friends come to spend a day or evening, there is just more of it set out. And since nothing matches—although everything looks good together—having enough (or the appropriate) china is not something I ever have to worry about. I do not, if fact, worry about *any* aspect of entertaining. Although I go to some thought and trouble to make everything pleasant, pretty, and celebratory, my first rule of entertaining is not to make myself so anxious that I don't enjoy my guests.

So I know—and set—my limitations. I keep the food I serve simple and choose from menus that can be prepared largely in advance; I put out all the china, silver, and glass that I expect to need and also use it as part of the decoration. And I fill my house with flowers.

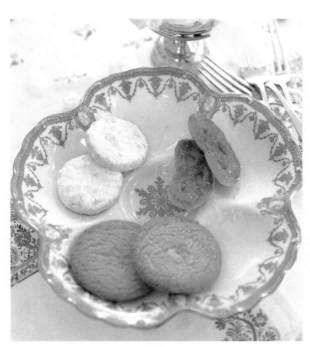

Above: A French Havilland oyster dish. To me it's as fine as a piece of jewelry.

Opposite: Beautiful but unmatched—a gaudy teapot, an elegant cup and saucer with a formal frieze pattern, a stack of berry bowls on a stack of assorted plates—more than this party needs, but I like the abundance and choice. The flowers, rescued from a broken stem, float in my silver goblets.

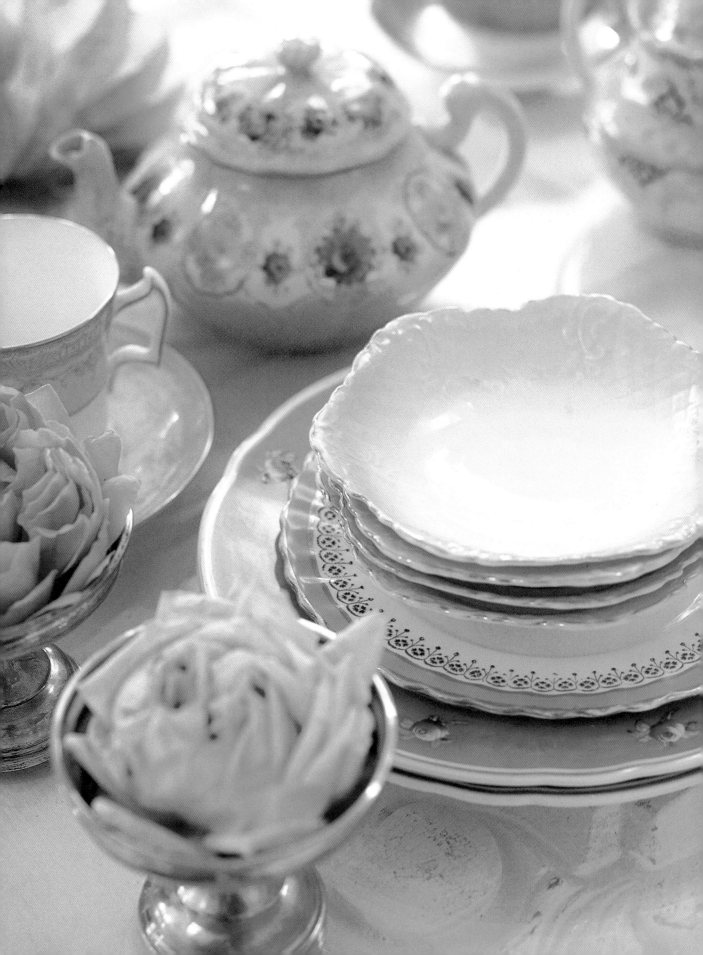

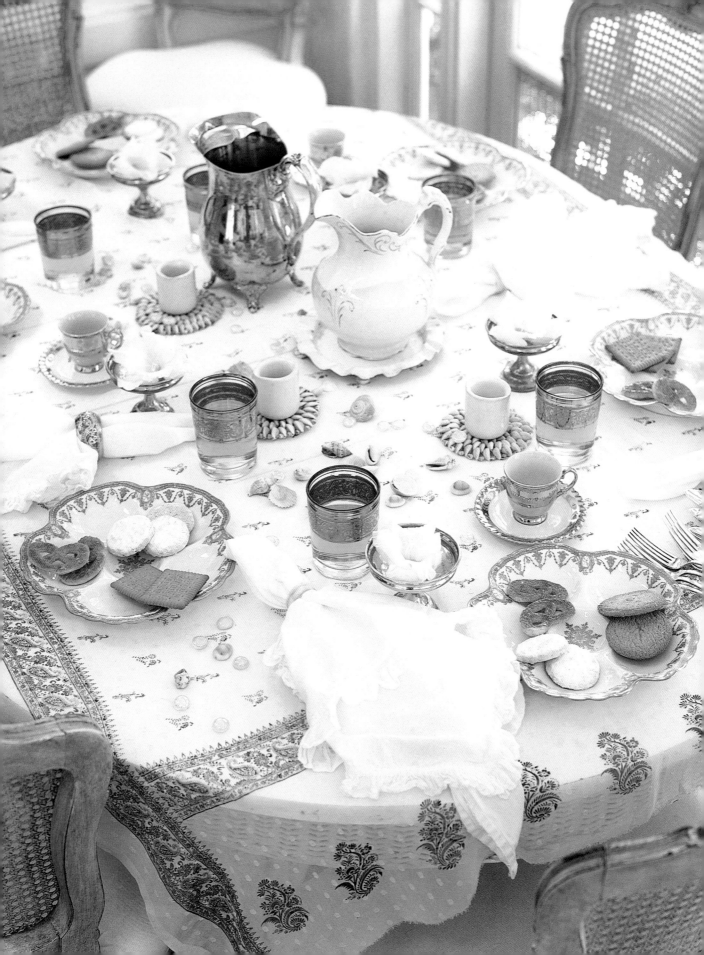

None of this need be particularly expensive, or difficult. I have limited dining space indoors, so I usually have my larger gatherings during the summer and entertain in the garden. I open the French doors and push my dining table between them; on it I place a cold buffet and a profusion of mismatched plates and linen napkins. My guests can serve themselves from either the garden or the living room.

Above: Festive ornamental Peruvian candles.

Opposite: This is as elegant as it gets in my house: gold and white china, silver, linen, and shells on an Indian sari. I like how the sari is so fine that you can see the table through it.

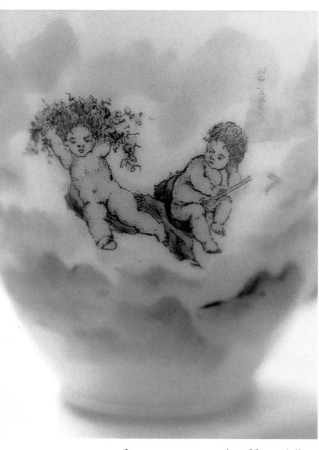

s i m p l e

The food I serve is simple and set out in a manner that makes it attractive. For a summer buffet, I might serve cold meats on a platter, and a variety of breads, salads, and cheeses, with a large fresh-fruit salad. For a smaller winter meal, say for six people eating at the dining table, I may cook chicken with roast potatoes and vegetables. Simple and delicious—I avoid sauces or last-minute preparation during the time I want to spend with my guests. For a tea party, it might be even more simple—tea, hot or iced, and an inexpensive cake, which I decorate with flowers.

The serving dishes, plates, and bowls my friends use have been collected over the years at flea markets, thrift stores, and secondhand shops. Very few of them have cost more than a few dollars: even now it is very rare for me to pay more than fifteen dollars for a plate; a pitcher or jug usually costs between fifteen and fifty dollars; and a really pretty cup and saucer shouldn't be more than twenty-five dollars. If you buy a dinner service that is incomplete, it will be considerably less expensive, and you can mix and match. If you live in a location where there aren't many flea markets or thrift shops, you can sometimes find what you are looking for through a china matching or replacement service (see Resource Guide).

 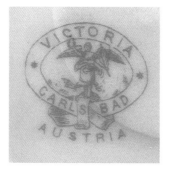

Above: The mark on the back of one of my cupid plates tells me it was made at the turn of the century in Bohemia. I bought each piece at a different time, and they are all different makes. Cupid is shown on these pieces as a sweet, if rather plump, baby, the most recent incarnation of the god of love. In Greek mythology he was Eros, son of Hermes and Aphrodite. The Romans called him Amor, and his parents were Mercury and Venus. In Hellenistic and classical art he was portrayed as a youth or young man. By the later Renaissance he was a small child, and then he became merged with the putti (winged infants).

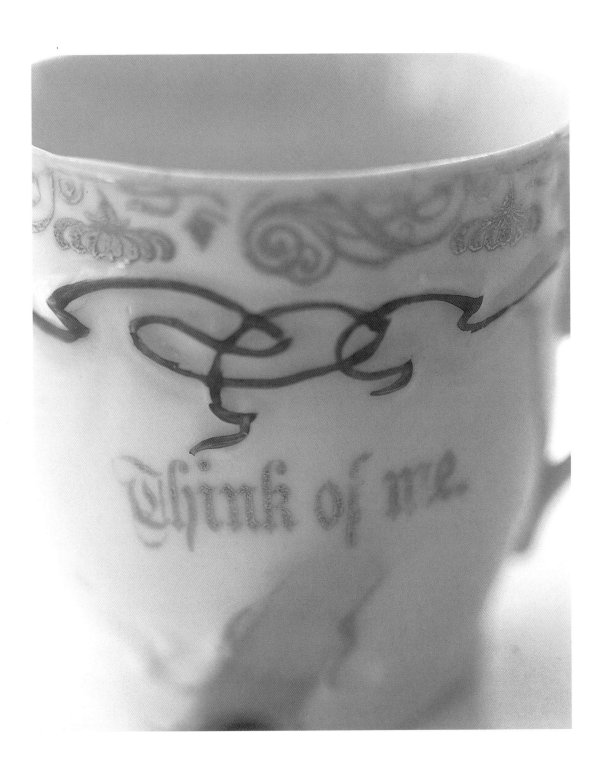

Think of me

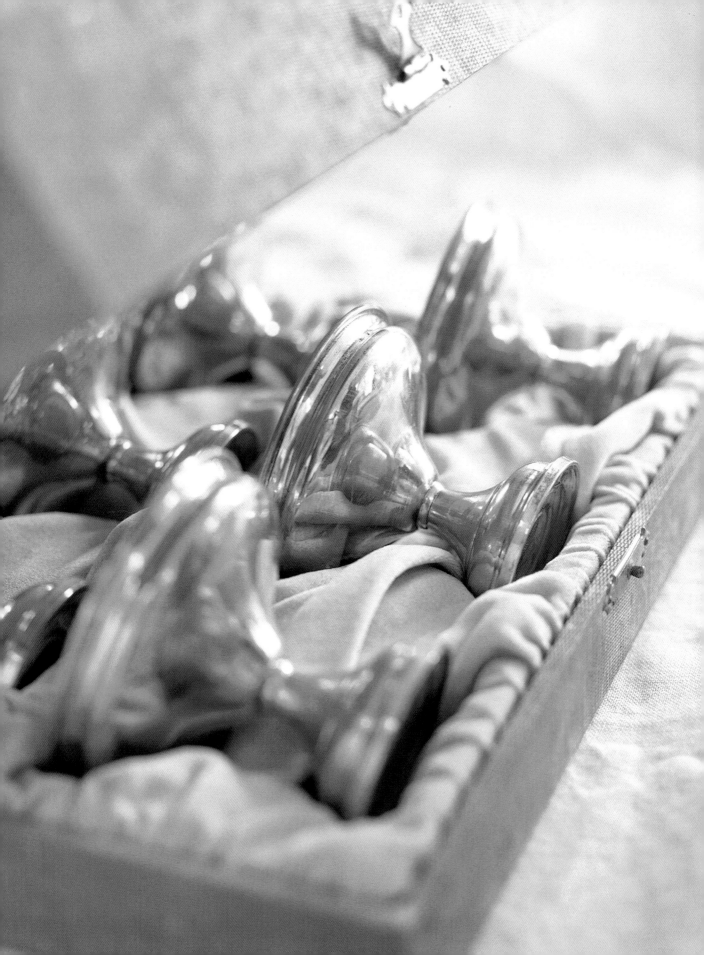

A table setting is nicely rounded out with mix-and-match antique silver and crystal. Again, buying individual, orphaned pieces is much less expensive—and also much more interesting (not to mention more fun)—than buying full sets. And the inevitable silver-spoon-meets-garbage-disposal confrontation isn't the tragedy it would be if the spoon were from an otherwise intact set.

Although I treasure my china, I use it and the linen napkins (also from flea markets) every day. I take great pleasure drinking from fine bone china and really don't like thick-rim mugs. The plates go in the dishwasher and the napkins in the washing machine. Both of these conveniences tend to take their toll, but I don't mind my napkins becoming thinner and the colors on my plates fading a little.

Sometimes I wash my china by hand, not as a chore but because I want to take an unhurried moment to enjoy it and take pleasure in the things that are part of my house and home. We all have busy lives and I am always grateful that I have help—Lupe, a gardener, and a pool cleaner. Nevertheless, I think it is important not to delegate all the household chores. Certain tasks are necessary so that I can feel I am living my life, caring for my home. Although I don't do it all the time, I like to wash my dishes, dust my house, make the beds; it gives me time to experience and appreciate my home.

Opposite: The box and wrapping of these silver goblets are almost as appealing as the dishes themselves. I like to use them as finger bowls, or to put one with flowers in front of each of my guests as tiny individual floral arrangements.

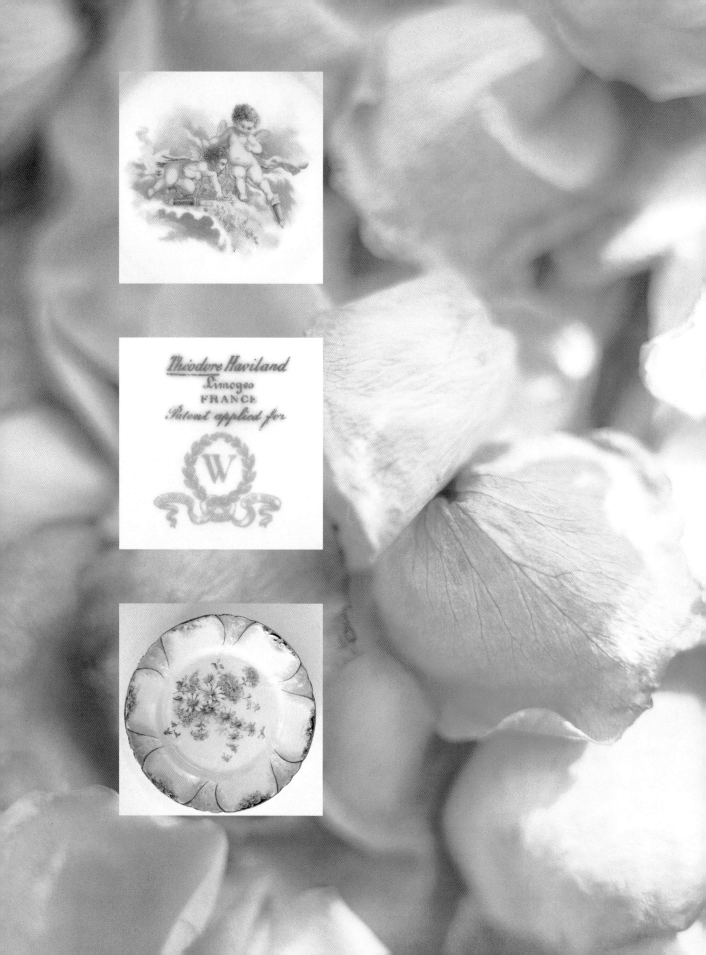

And there are two exceptions to my "put everything in the dishwasher" rule. My Havilland oyster plates—part of a set, made in Limoges, France, especially for a jeweler—are family treasures. I prefer to wash them by hand; but we do use them for everyday. The other exception is my cupid china collection. I bought each of these pieces at a different time, finding them at flea markets or secondhand shops. When I buy a piece of china the last thing I look for is the mark. But when I have found something I love, and it has a china mark, it is fun and interesting to be able to look up when it was made, where, and by what factory. Good pottery and porcelain bears the maker's mark on its reverse side. The mark may be a name or a cryptic symbol, often both. If you know how to read the mark you will be able to tell where and approximately when it was made. *Kovel's New Dictionary of Marks* (see Resource Guide) is a useful reference. The marks themselves, especially the older ones that seem to have blurred or bled into the glaze, are frequently lovely, and often of my palette. My Havilland oyster dishes are marked, but only one of my cupid plates is.

Before I arrange my table, I choose a theme: it could be a mix of colors, gold and white, or pink, or all white; or it could be all floral; or only cupids. While I am a firm believer in mixing and matching, a table (or even a cupboard) should not become a mishmash of leftover plates and cups.

I also set out flowers. The cost of having them around varies with the season and, of course, with location. Buying flowers in the middle of a California summer costs a great deal less than it would in, say, December in Chicago. In either case, it does not have to be a major extravagance so long as you remember that you don't have to have an enormous number of flowers for the right effect; you can choose flowers that last, and look after them properly.

A moiré dress. The color, the lace, the ruffles, the pleating—I find it irresistible. Dresses such as this can be bought for pennies.

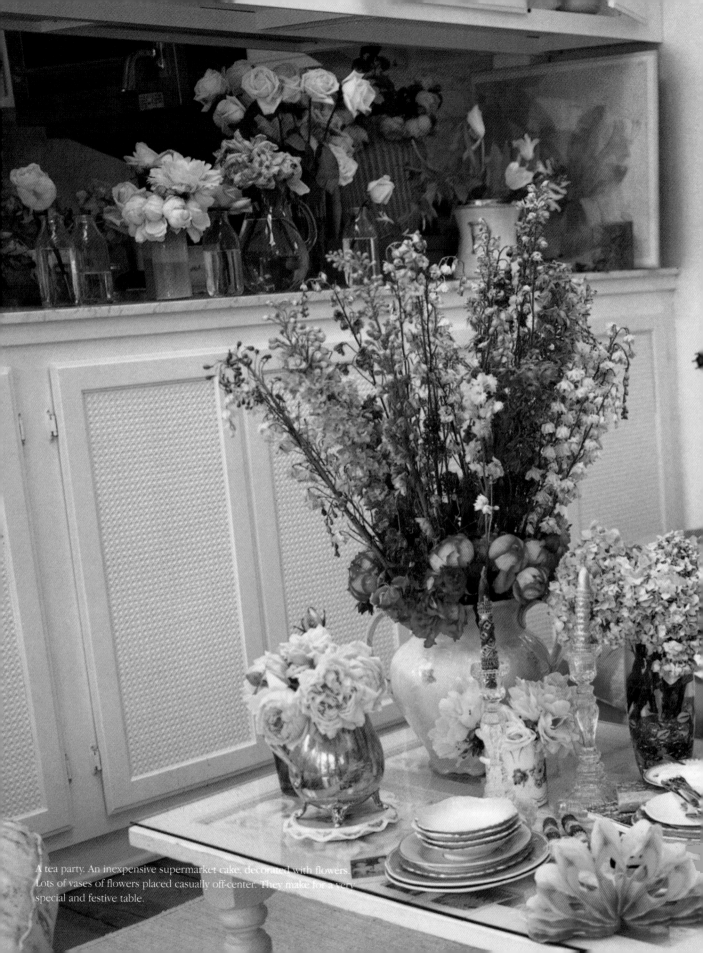

A tea party. An inexpensive supermarket cake, decorated with flowers. Lots of vases of flowers placed casually off-center. They make for a very special and festive table.

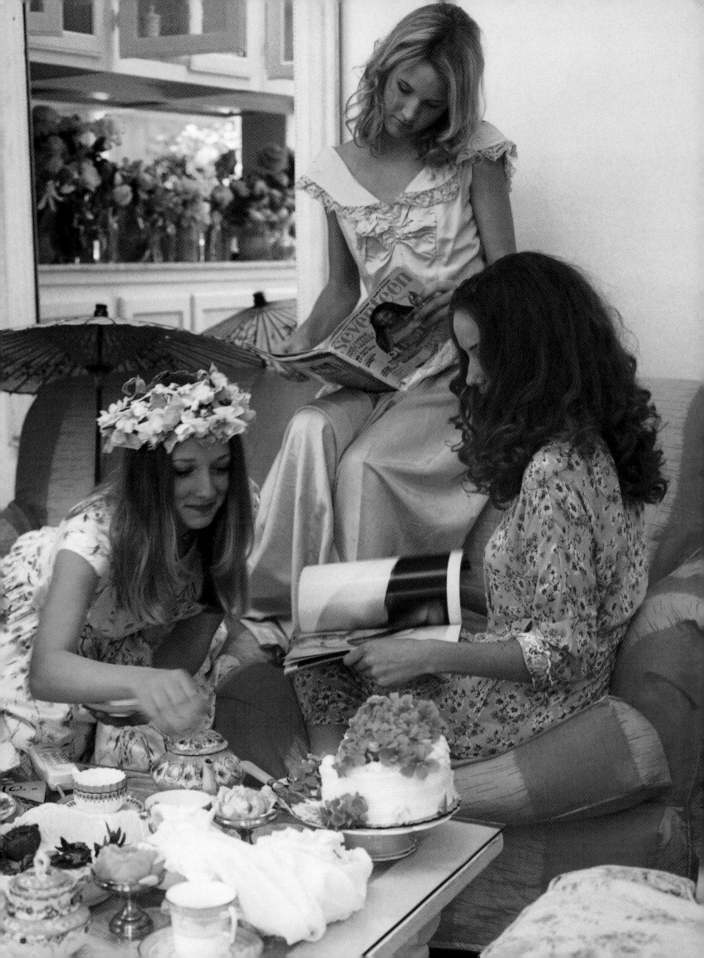

I like to cluster my flower vases, maybe three different sizes set off-center on one table. And when I am serving a sit-down dinner, I like to place one bloom in a bud vase in front of each guest. Bud vases are very cheap, or you can often find a pretty old jar or bottle. I avoid a large centerpiece on the dining table, where it gets in the way of seeing the person opposite you.

The willingness to improvise makes entertaining less expensive and more fun. If you don't have the right kind of tablecloth, find a pretty cloth that has another function—perhaps a curtain; one of my favorite decorating ideas for a table is the use of an Indian sari. I add my flea-market silver, some shells, flower petals, sea glass, marbles. Again a theme, but uncontrived and haphazard. I like to make an individual decoration for each place setting, a whimsical personal arrangement for each guest. The key to a successful individual style is being creative with what you already have.

And what to wear while entertaining? Flea markets and vintage-clothing shops are brilliant sources for dress-up clothes. I have a collection of lovely festive dresses from the forties and fifties; some are only for fancier occasions, but many become constants in my wardrobe. My favorite fabrics are rayon, cotton, and silk taffeta, and I keep an eye open for dresses with pretty ruffles or pleats. Hats also can be fun; they don't need to be dramatic, especially if you keep them small.

Vintage tea dresses—cotton, rayon, and moiré. Fun for dress-up. Or everyday wear.

CHINA MATCHING & REPLACEMENT

One of the beauties of collecting and using old china is that it can be inexpensive, particularly if you use mismatched pieces, which can be aesthetically great. It is much cheaper to buy a dinner service that is incomplete. If you want to complete it, or if you find a piece that you love so much you want more of it, you can use a china matching and replacement service.

There are many such services, and it is not difficult to find one that specializes in the make and pattern that you are seeking; look in your Yellow Pages for a local service. The larger companies with 800 numbers often advertise in magazines, or can be found on the Internet.

Replacements, Ltd. in Greensboro, North Carolina, has the largest inventory of old and new china (as well as silver, crystal, and collectibles). Their inventory of six million pieces includes more than 120,000 patterns. They also offer:

- gift certificates
- layaway plans
- a search service—they will look for a rare piece and call you when they find it
- collect calling

- showroom
- guided tours
- catalog
- Web site
- free pattern printouts with prices

Some of the smaller, more specialized companies also offer one or more of these services.

Above: I buy plates for what they look like, but I think the marks on the back, which tell when and where they were made, are beautiful too. I love the way the colors, lettering, and crests sometimes have blended and blurred into the glaze.

Opposite: A fun, festive rather gaudy gold cup.

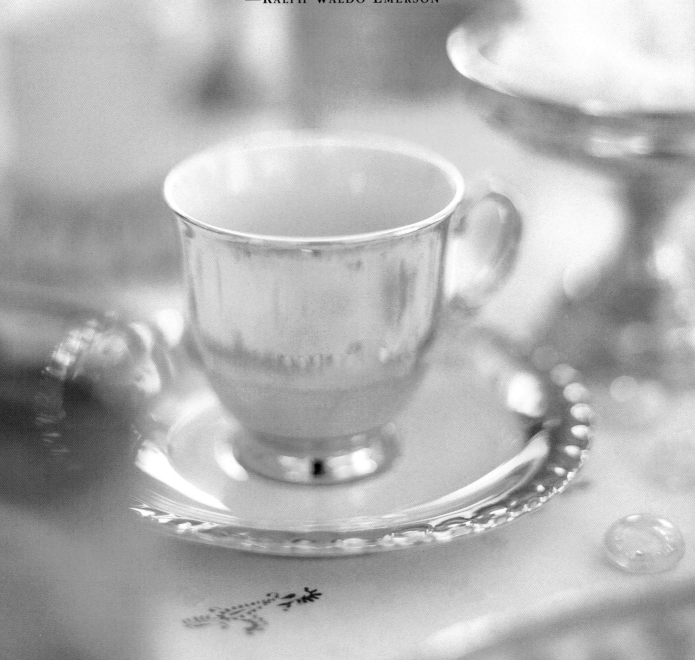

The ornament of a house

is the friends who frequent it.

—Ralph Waldo Emerson

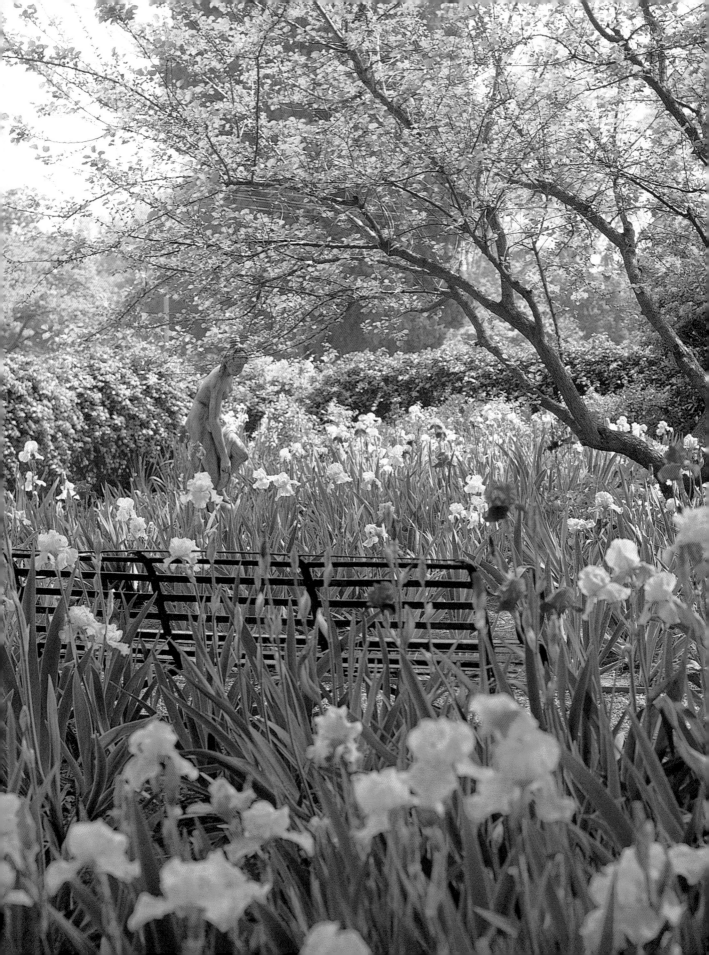

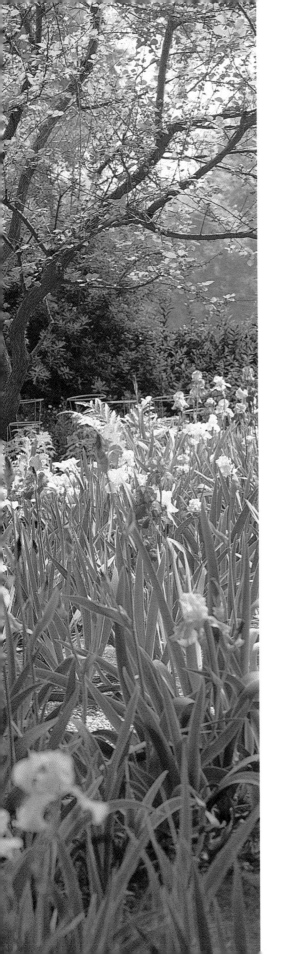

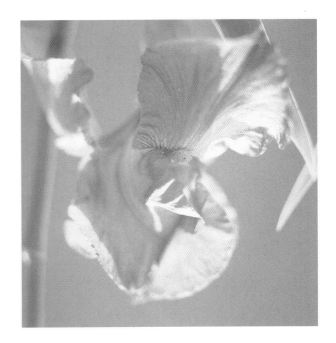

6

FLORAL THINGS

Flowers are one of the greatest and most satisfying indulgences of life. I love those growing in my garden, and I love arranging cut flowers; I enjoy setting out my collection of vases and creating arrangements for every room in the house. I even enjoy it when I am so busy that I haven't time to arrange my flowers the day I get them, and so they sit in large, cool buckets for a day, or sometimes even two, luxurious and beautiful in their bunched profusion.

My garden is an explosion of texture and color, perfectly suited to the grounds: elegant morning glories and romantic roses, the tropical splendor of honeysuckle and the color explosion of wisteria, all amid lush foliage and the dappled sunlight admitted by the trees. And I cut nearly everything for indoors—from hydrangeas and camellias to the azalea blossoms that I sprinkle on my daughter's breakfast tray.

Opposite: A silver pitcher, found at a flea market, full of sweet peas. So fragile, so precious.

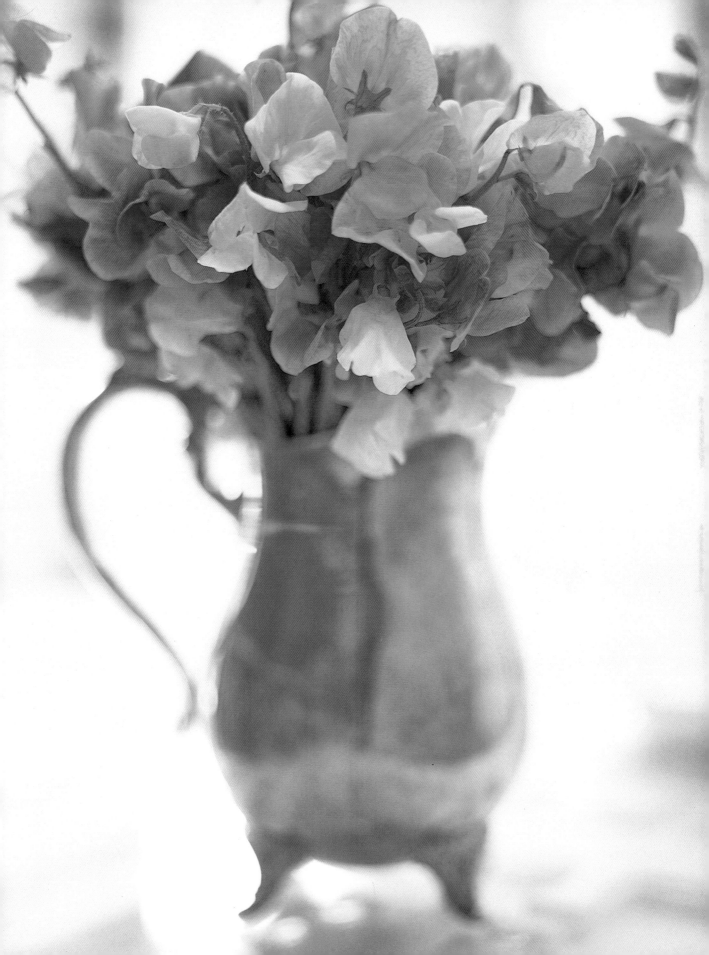

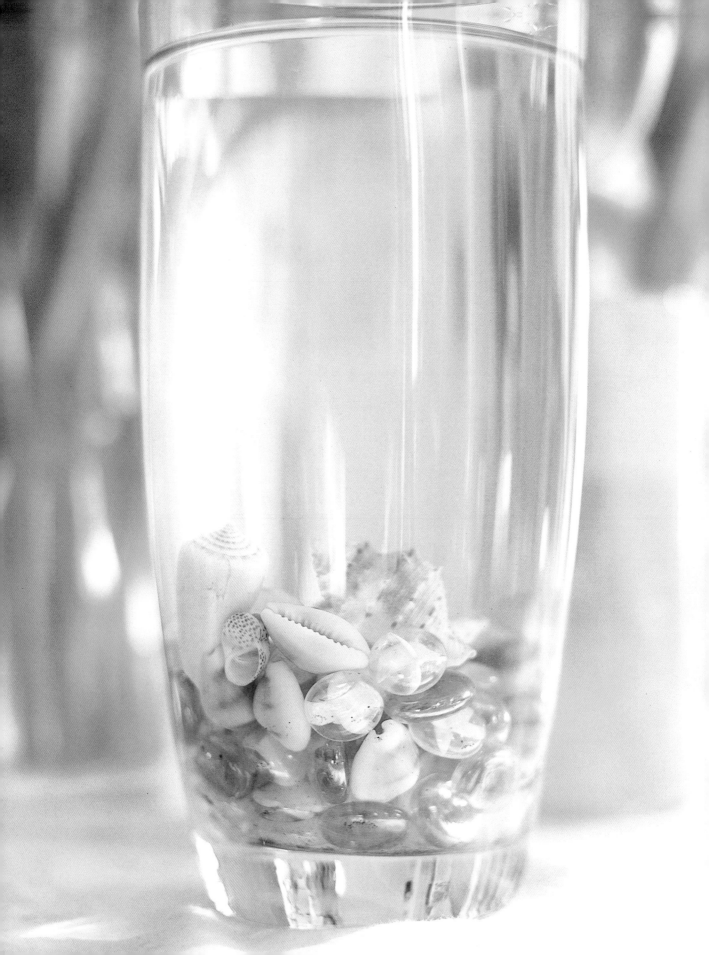

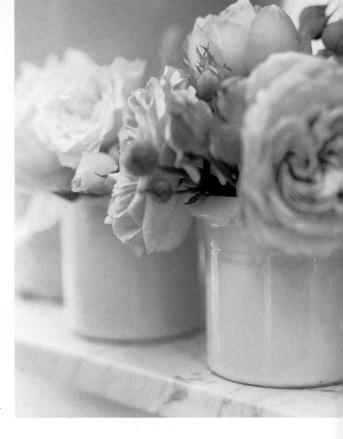

I have a large collection of vases, acquired over the years at flea markets and secondhand shops. Sometimes a treasure from my china cupboard—a chipped jug or a teapot that has lost its lid—will find a new life among my vases. I have one or two clear-glass vases whose shapes are useful but whose appearance is a little dull; these I make more interesting by filling the bottoms with colorful shells or stones.

I have flowers all over my house, in all the expected and unexpected places, all carefully placed, and never centered—I prefer them off to one side. Roses, peonies, hydrangeas, sweet peas, and tulips are among my favorites. I particularly like putting oversized flowers such as roses or peonies in small vases and clustering them in groups.

My children have grown up with lots of flowers in the house. Jake used to resist my attempts to include his room when placing my flower arrangements, but from time to time he'll accept a brown vase with white flowers, usually tulips or roses. Over the years he has learned the names of quite a few flowers—knowledge that may come in handy someday. When I take Lily her ritual tray of tea and cookies every night, I always put a flower on the tray; now that she is old enough, she brings me little treats on trays too, always with a flower.

Above right: English cream pottery. A small grouping is lovely.

Opposite: A boring glass vase. I fill the bottom with pretty stuff. In this vase I have put pink and white glass marbles and shells.

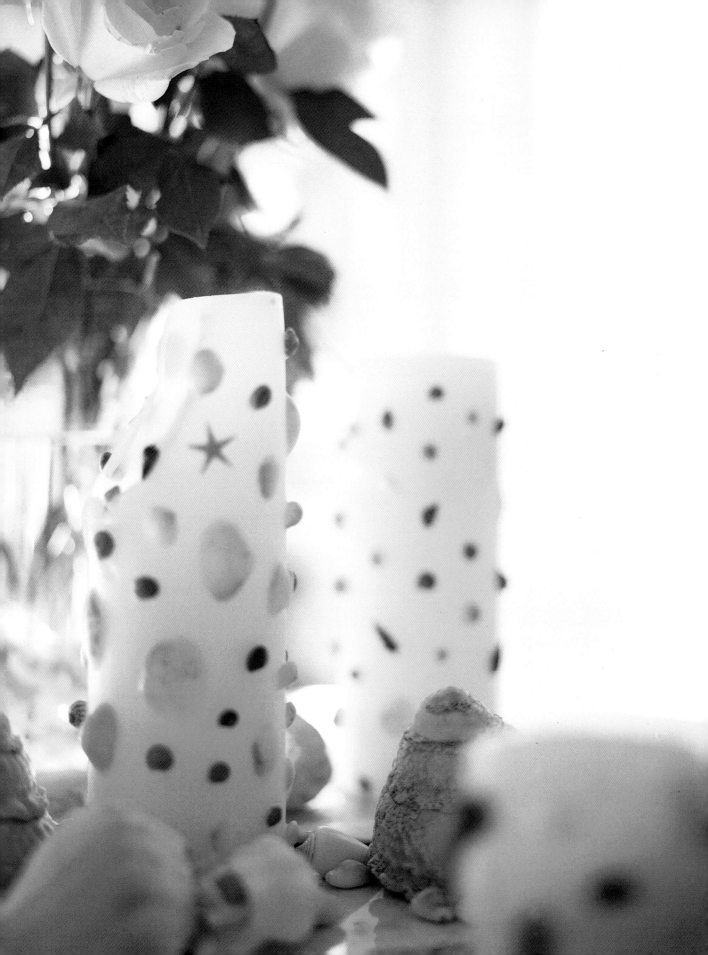

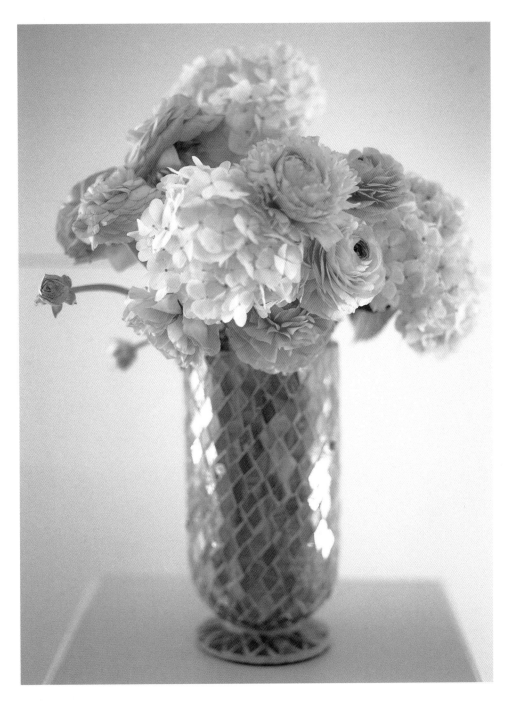

Above: Luscious flowers: hydrangeas and ranunculus. I took the hydrangea blooms from a really inexpensive plant; once cut, the flowers lasted about three weeks and I still have the original plant in my garden!

Opposite: Monochromatic: white flowers, white shells.

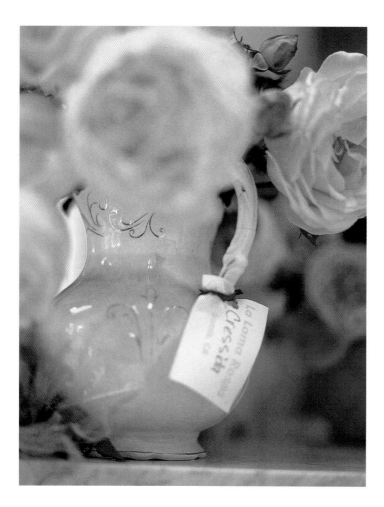

Having a house full of flowers is one of the great pleasures
of life, and even if you don't grow your own, they don't have to be
expensive. It is only necessary to shop carefully, and to look after
your flowers once you've brought them home.

For me, a rose has the most varied life span, beautiful as a bud,
in full bloom, and even when overblown as the petals start to drop.
A bunch of roses is lovely, but so is a single bloom in a bud vase. My
garden is planted with mature old-fashioned roses, and there is
nothing more special than picking my own flowers. When I bought
my house many of the roses were yellow, but my gardener Laura
swapped them for colors that belong in my palette.

Above: A slightly imperfect gold-and-cream pitcher. The water bleeds
through, marking the china, but the pitcher is still watertight for flowers.

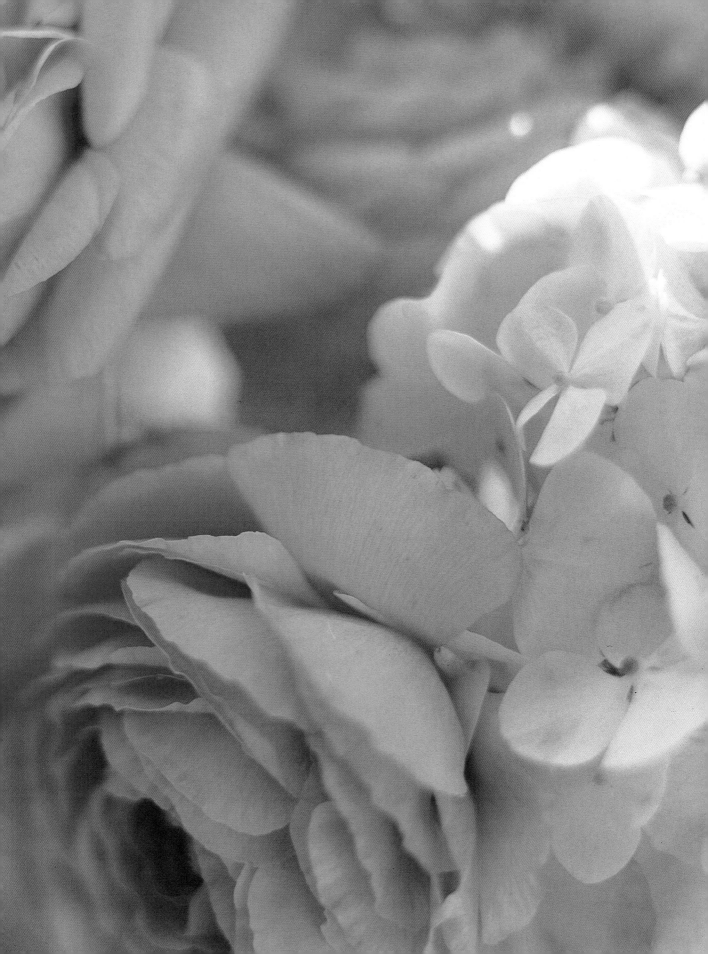

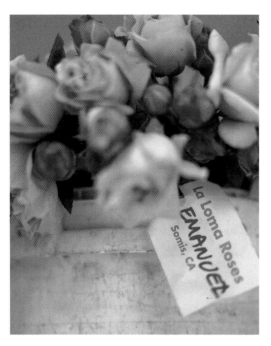

Roses from La Loma farm, owned by my lovely neighbor Kristi Stevens.

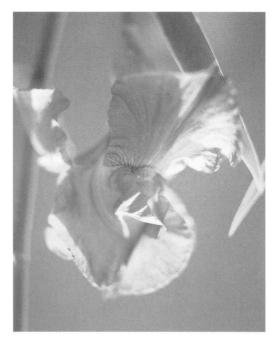

A bearded iris.

Part of a Japanese streamer. I love the faded and irregular colors, the floppy folds.

Tiny flowers on a delicate plate echo the pale cloth underneath.

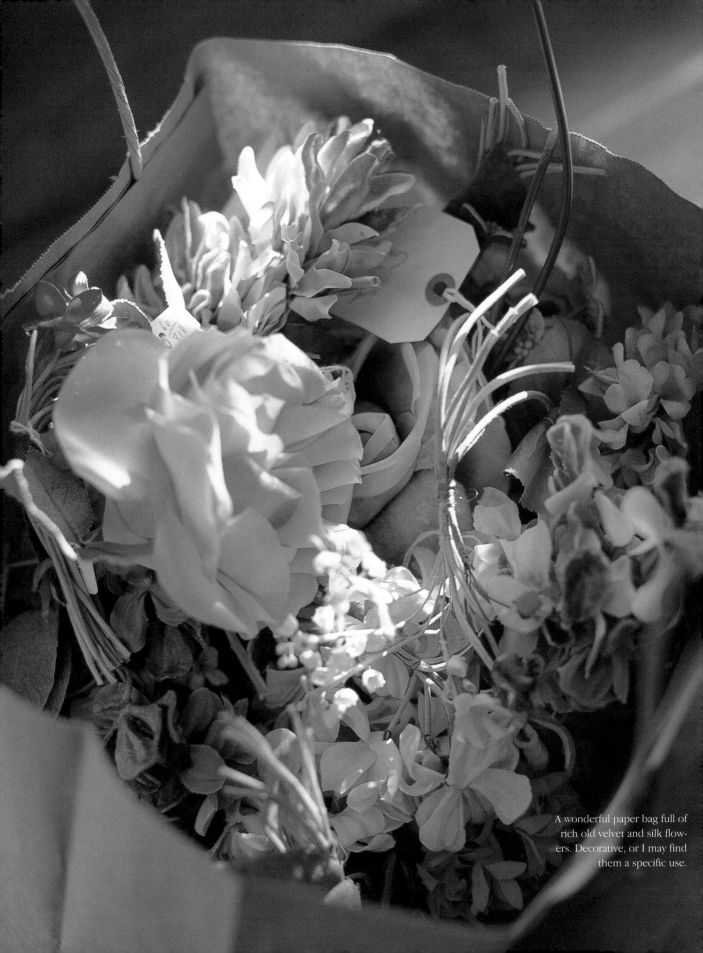

A wonderful paper bag full of rich old velvet and silk flowers. Decorative, or I may find them a specific use.

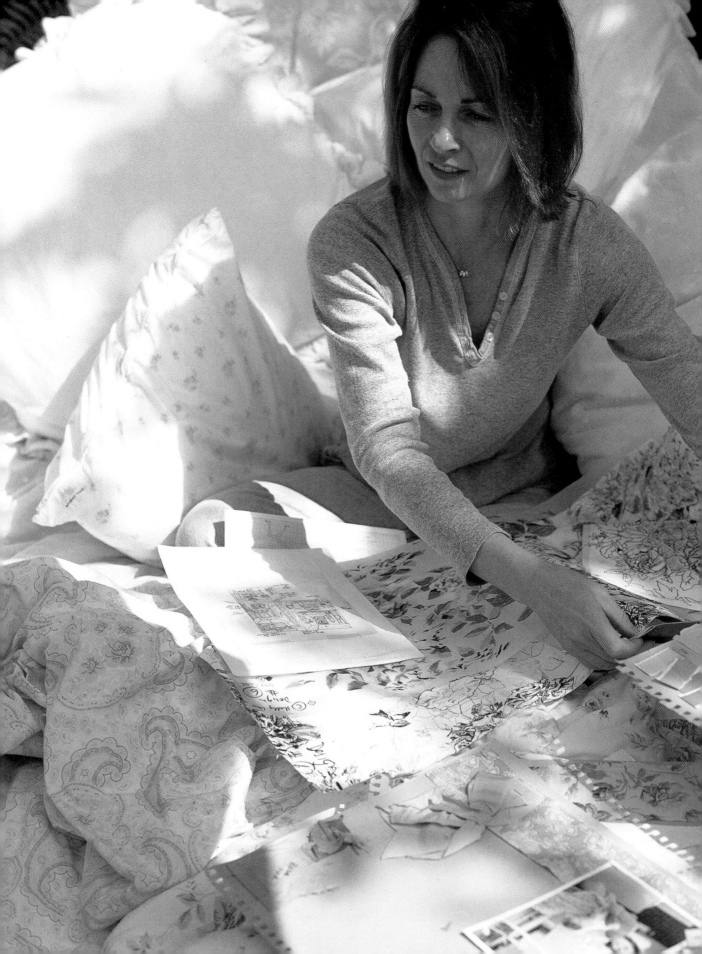

v i s i o n

Flowers are not only one of the great pleasures of my life, but their inspiration is a central part of Shabby Chic. Their influence can be seen in everything I design—there is very little in the fabrics, bedding, decoration, and colors I use that doesn't somehow come from flowers. The inspiration boards all over my house have flowers and floral references on them; my china, my dresses, my decorations are all floral. It is a rare moment that a flower, in some form, is not in my line of vision.

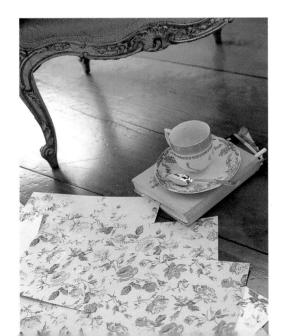

Top: I found this not very Shabby Chic throw pillow at a flea market. The design and dramatic size of the flower became the inspiration for a Shabby Chic fabric pattern called "pale bunch."

Opposite: My deck is a perfect place to review some artwork for a new Shabby Chic fabric—out-of-doors, close to the original inspiration!

Getting Full Value out of Flowers

- It is not always necessary to buy flowers at a florist. If you are careful that they are fresh, good flowers can be bought at a corner market, or even a super-market. You may be fortunate enough to have a farmers' market nearby, and these are good sources for seasonal flowers.

- A small quantity of flowers imaginatively used (in a cluster of bud vases?) can be as effective as a larger bunch.

- Choose cut flowers that have a long life. For example, a rose will last many more days than an iris. Hydrangeas and orchids are also flowers I love that can last a long time.

- To extend the life of cut flowers, trim the stem of each daily, either cutting under warm water or replacing the flower in the vase quickly. Snip off all leaves or thorns below water level. Slice the stems at an angle using a paring knife, not scissors, which can crush the stem.

- Use the sachet that comes with the flowers, or bleach, to keep bacteria out of the water.

- Change the water every day, and then wash the vase thoroughly after you throw out the flowers.

Opposite: The green frilly neck of this vase is, to my eye, beautiful. A collar of green for my silk roses.

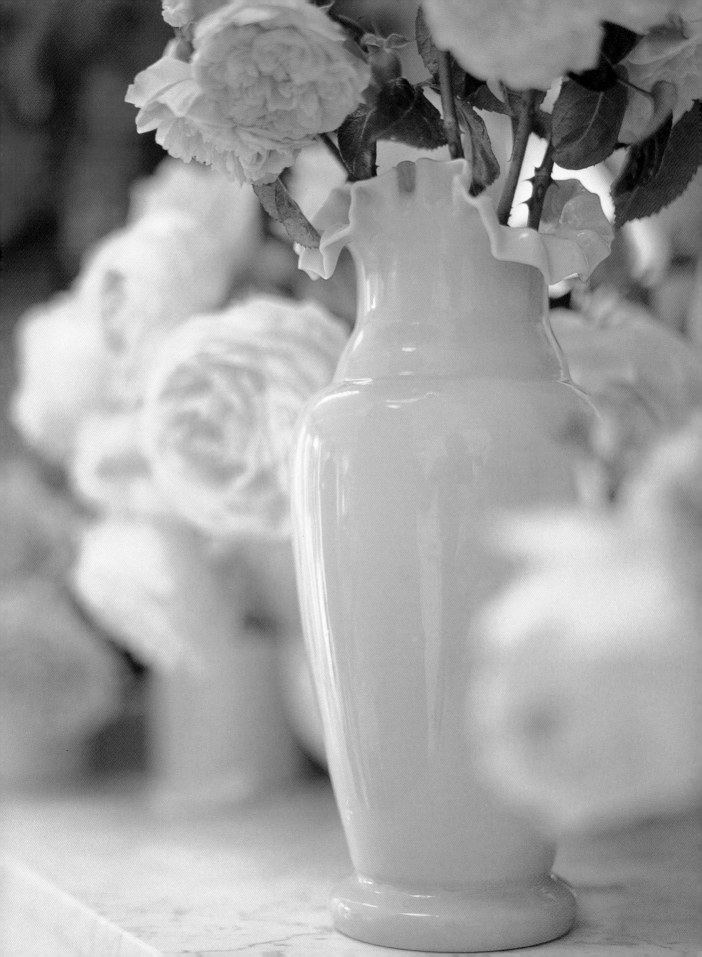

a c c e n t s

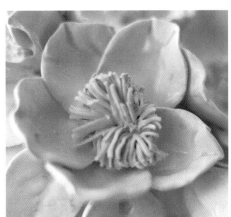

Top: A beaded butterfly and an Indian bracelet.

Bottom: Velvet fruit, ceramic flowers, fabric butterflies.

Opposite: Another of my inspiration boards.

Paper butterflies.

helping hands

Ted, Syl, Kevin, and Chris—I couldn't
have done it without them.

*There is nothing like a dream to
create the future.*

—Victor Hugo

Resource Guide

RACHEL ASHWELL SHABBY CHIC COUTURE
1013 Montana Avenue
Santa Monica, CA 90403
(310) 394-1975
scsm@shabbychic.com

RACHEL ASHWELL SHABBY CHIC COUTURE
17 Mercer Street
 New York, NY 10012
(212) 334-3500
scny@shabbychic.com

RACHEL ASHWELL SHABBY CHIC COUTURE
5808 Wagner Road
Round Top, TX 78954
(979) 836-6907
sctx@shabbychic.com

RACHEL ASHWELL SHABBY CHIC COUTURE
202 Kensington Park Road
London, UK W11 1NR
(+44) 20 77929022
scln@shabbychic.com

http://www.rachelashwellshabbychiccouture.com/
http://rachelashwellshabbychic.blogspot.com/
http://theprairiebyrachelashwell.com/

The
GOLDEN TOMORROW

Today is the golden Tomorrow
that you dreamed of Yesterday—
and so it will be until the end
of Time. This day, then, is your
Day of Opportunity!

COPYRIGHT 1938